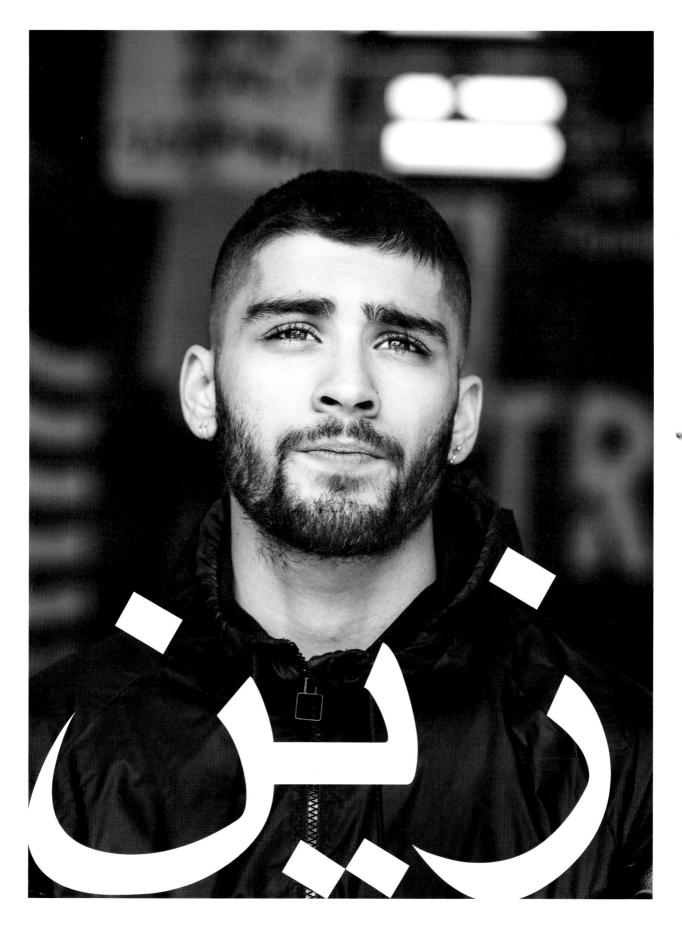

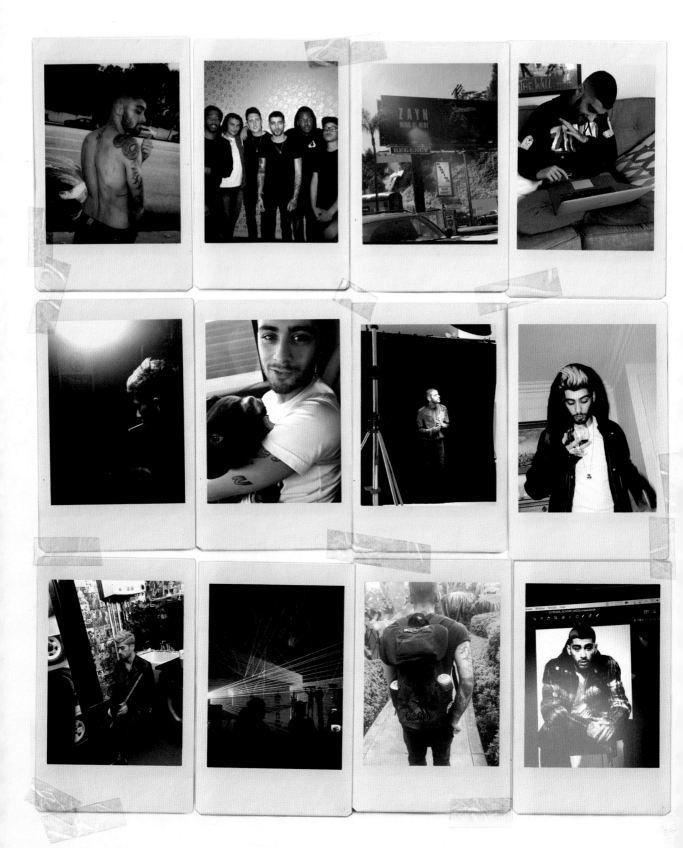

# ZAYN

PENGUIN BOOKS

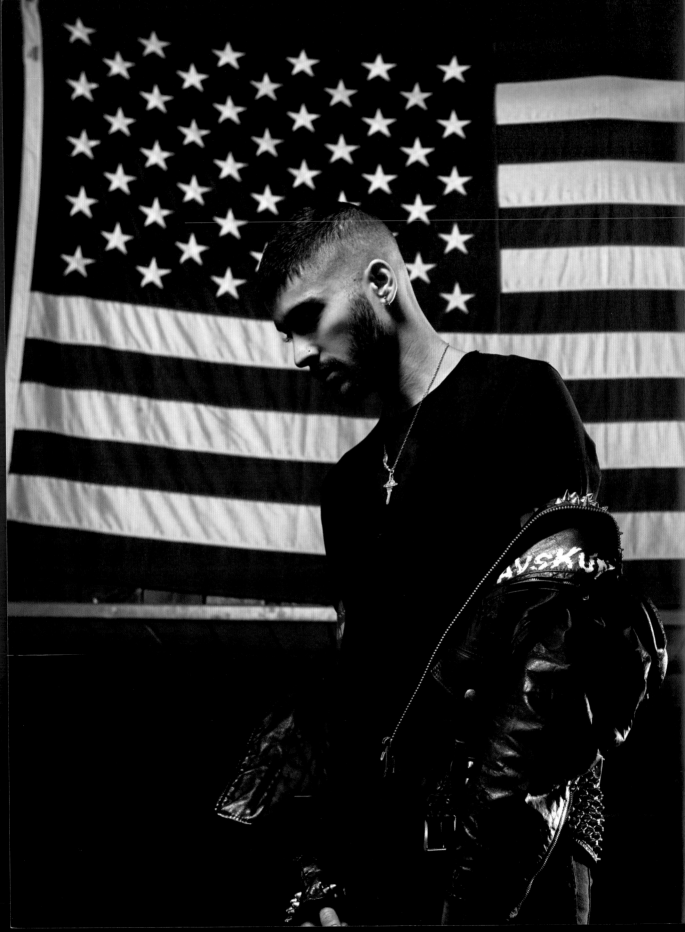

# CONTENTS

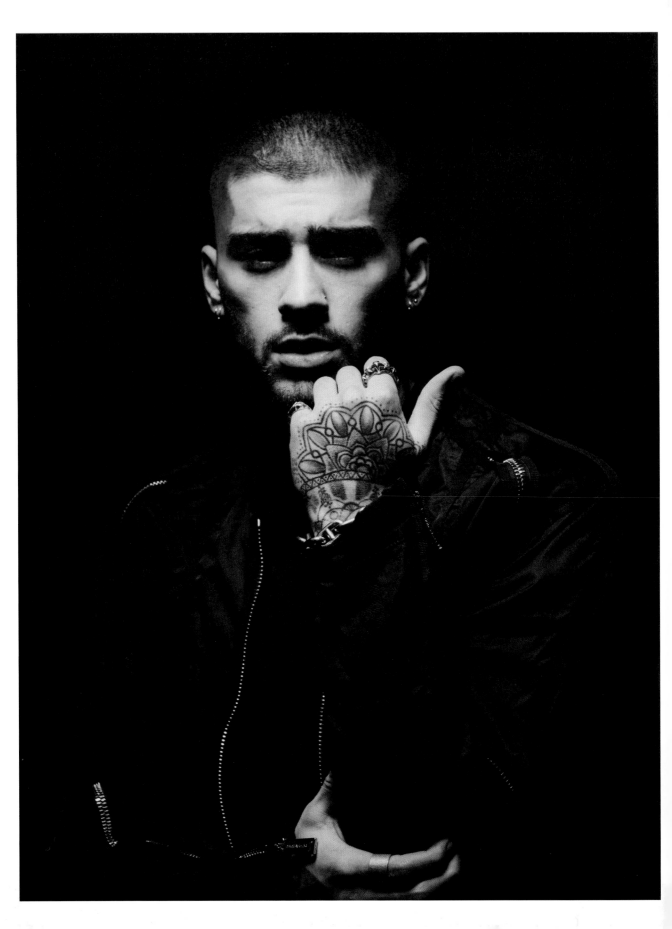

# PROLOGUE

One Direction changed the course of my life. I'm
a mixed-race, Muslim musician from Bradford.
And by a stroke of fate or luck, or whatever
name you want to label it, I was blessed
to spend five years in a band that had
a hundred number-one records, 100
million album sales, and gigs playing
to around 10 million fans. One
Direction was my bridge from
being a crazy, lazy teenager
with a creative passion to
embarking on an insane
adventure in a world
I never thought I'd
know. My name is
Zayn Malik and
this is my story.

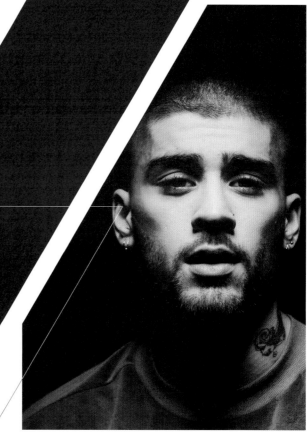

# 01.

# FREEFALL

'I was just being expressive in my own style, and I certainly didn't expect anything of what I was doing to take me anywhere exciting, not like it has done in the past year.'

# 'I FEEL LIKE THERE HAS BEEN A LOT SAID ABOUT ME AND WHY I LEFT ONE DIRECTION.'

It's kind of surreal when you spend five years identified with such a successful band to then have the freedom to make choices on your own. From the moment I left One Direction, everything changed. Suddenly, I was on my own, which was something I hadn't been for all those years. I spent a few months recording sessions with some people I knew and had worked with in the past. I met with some producers who I thought might be able to help me create the songs I'd had in my head since I was seventeen. But, to be honest, I had no idea what I was doing. I'd been writing my own stuff while I was in the band, it wasn't a new thing, but I had to work out what I wanted to show people, what I wanted to say. Every lyric has to mean something to me, and it's been a long process to find a way to make the most of all my insane opportunities, to take the positives and try to let go of the negatives and to finally bring something out that genuinely reflects me.

I feel like there has been a lot said about me and why I left One Direction. At times it's been difficult to get across what was going on in my head at that point in my life. I guess that's why I'm writing this now. Not because I think I'm so great, or because the whole world needs to know about Zayn Malik, but so that, if you're at all interested, you can understand a bit better why I did the things I did and where I'm at now. The fans deserve answers, so I'm going to try and give them. If you know anything at all about me, other than that I'm 'that one who left 1D', you probably know that I'm not usually one for talking. Interviews have never exactly been a talent of mine, and I tend to keep things quite private. But I'm going to show you as much as I can so that you can judge me on my own terms, not on what the press or anyone else says.

You might think that leaving the band was this time of massive excitement for me, because I was finally free to do what I wanted, but, if I'm straight with you, it didn't feel that way. To tell the truth, I was pretty lost. I definitely knew I wanted to make my own music — that was the only path for me — but I felt like I was adrift. Everything that I knew of the industry — the boys, the crew, management, legal — that all went the day I left the band. I take responsibility for leaving, of course, but it was still massively disorientating. All of a sudden, it was just me and my thoughts, and that was fucking terrifying. I would spend long hours on my own, just trying to process what the hell I was going to do next. Looking back on it, I think I needed that time, that introspection that comes when everything you've known for nearly half a decade falls away. Eventually, I realized I needed representation. I got lucky when my PA introduced me to a new management company run by a whole team of women. I was raised mostly by women, so this felt good. I had support again, and support I could trust. They understood what I wanted to do, the music that I wanted to make, and I knew instinctively that they were the right people to help me.

One Direction made great pop, there's no denying that. But it's no secret that that kind of pop music really isn't my thing and towards the end of my time in the band, I was becoming more and more desperate to express my own style and write lyrics about stuff that I really believed in, rather than the melodies and beats that were being made for us in One Direction. What you've got to understand is that none of us really had much say in the music. At least, not at the start. If I suggested singing a line or a hook in a more R&B way, that would get smoothed out into a more poppy approach, because that was the music that was expected of us. Even as we matured and the other lads began to develop their sound a bit more, I found that it wasn't in sync with my own. I stuck it out because the support and all the positive responses we were getting from our fans around the world were incredible, and I respected that it was working for my band mates. To be honest, though, it was a struggle for me, the fact that we didn't share the same musical taste. It felt a bit like being forced into a mould I would never fit. I wanted to be in the studio singing lyrics that resonated with me, not just repeating someone else's lines.

As a band we toured the world many times over. That's a lot of time spent on tour buses and planes, and that's when I'd get creative. There were long hours in between shows when I'd lock myself away and just write and write on my own. Whenever I saw a window to write I'd grab it, even if it meant working really late into the night and even if I knew it wasn't material that we would end up using as a band. It's important to say, though, that this wasn't part of some big master plan to break away and go solo. I wasn't thinking about a solo career, I was just being expressive in my own style and using the downtime we had to do what I love doing most. In hindsight, what I realize now is that being in One Direction gave me the opportunity to understand what it was that I needed to do – and that was to find my own sound. It was only towards the very end of my life with the band that I actually started visiting studios by myself, just to mess about and experiment. It felt important to be more in control of my time, doing less of what other people had decided was right for me, or for them, and more of what I felt was right.

'I WANTED TO BE IN THE STUDIO SINGING
LYRICS THAT RESONATED WITH ME, NOT JUST
REPEATING SOMEONE ELSE'S LINES.'

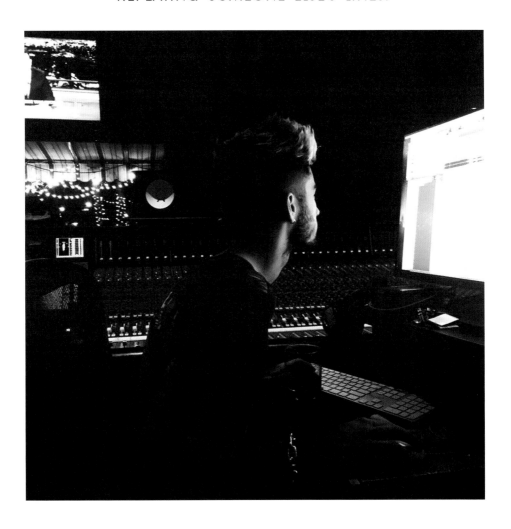

The biggest obstacle for me after I left and when I first considered releasing my own stuff was that I hadn't really figured out my sound yet. I had some solid musical building blocks and lyrical ideas, but nothing more. I suppose that makes sense – I hadn't exactly had much life experience when One Direction started. I was a boy from Bradford who showed up at an *X Factor* audition. I had dreams of being a solo artist, but I had no clue about the industry, how my career would work out or what it would actually take to make it. The next thing I knew, I'd been put together with four other boys and One Direction was born. We were swept away on this mad journey where we played to sold-out arenas and were mobbed by fans everywhere we went. It was pretty overwhelming.

Being in One Direction opened up an insane new level of opportunity for me, but it also sent me headfirst into a world that I had never experienced before, and that was very daunting. Before going on *X Factor*, I'd never even been to London, let alone on a plane flying halfway across the world. I remember my first flight – I was really nervous about it, and it didn't help when the boys thought it would be hilarious to convince me that the plane would do a loop-the-loop after we took off. I nearly shit myself. Obviously they were just having a laugh, but the fact that I believed them goes to show just how naive I was. It's not that I had been cocooned as a kid, but I had grown up in a city where, for a lot of people, there wasn't necessarily any expectation of ever getting out. I consider myself lucky that I got that chance. It was an adventure for the five of us boys, who were all from relatively humble backgrounds, and we definitely embraced the opportunities we were given. But no matter how far we travelled, I never lost that feeling that I was something

> 'I CAN SEE I WASN'T READY TO BE A SOLO ARTIST AT THE AGE OF NINETEEN, TWENTY, OR EVEN TWENTY-ONE. THOSE FIVE YEARS WITH THE BAND WERE ESSENTIAL FOR ME AS A YOUNG KID LEARNING ABOUT THE INDUSTRY.'

of an outsider. Maybe it was being from Bradford, maybe it was my accent, maybe it was my mixed-race heritage, my religion – I don't know. But everyone around us, the management, the record label, the lawyers, all seemed so posh in comparison to us. Everything I had known before was replaced with something alien, and that can be disorientating. I grew up in a really tight-knit family and, on top of everything else, it was difficult for me to suddenly be so far away from them. Out of nowhere, life had turned into this mental rollercoaster of unfamiliarity and uncertainty, and even though I was well up for the challenge, at the same time it was terrifying.

That's not to say that it wasn't fun at times. It was. All five of us would hang out, play football and generally have a laugh. At that moment, our lives felt so exciting, and that shared excitement created a real bond between us. Whenever we made a new track together, even though it wasn't my kind of music, I would still enjoy the experience of it, playing the new mixes for our latest singles at home or in the car, really loud, over and over, thinking, 'Fuck, we did that. That's us on that record.' I got to meet amazing fans, and I can never thank all of them enough for the love and support they gave me during the good times, and the bad. I can honestly say I'm proud of a lot

of stuff from the One Direction days. I'm not sure people realize that, but I am. I've got the memorabilia — the platinum discs we received with every album — all over my house. I have a wall dedicated to displaying them. One Direction was an incredible experience in its own right, and it's a part of me, an integral part of my history, and I'm never going to deny that aspect of my life.

But in terms of the music, I just didn't feel inspired. A lot of the time I just went along with it because I was still learning what worked, like a formula almost, and as time went on I began to appreciate that what worked for One Direction, the band, just didn't work for me. I guess when you're in the studio with these really experienced producers and a bunch of people all having their say, it can be difficult to work out how to contribute, especially at the start, when everything was so new and unfamiliar. With hindsight, I can see I wasn't ready to be a solo artist at the age of nineteen, twenty, or even twenty-one. Those five years with the band were essential for me as a young kid learning about the industry. Recording and touring those four albums — *Up All Night*, *Take Me Home*, *Midnight Memories* and *Four* — and working with incredibly talented people challenged my character, made me stronger and taught me what it takes to be a performer. I witnessed prolific songwriters at work and got first-hand experience as a recording artist, all with the boys by my side. I'll always be grateful for that.

'IN HINDSIGHT, WHAT I REALIZE NOW IS THAT BEING IN ONE DIRECTION GAVE ME THE OPPORTUNITY TO UNDERSTAND WHAT IT WAS THAT I NEEDED TO DO — AND THAT WAS TO FIND MY OWN SOUND.'

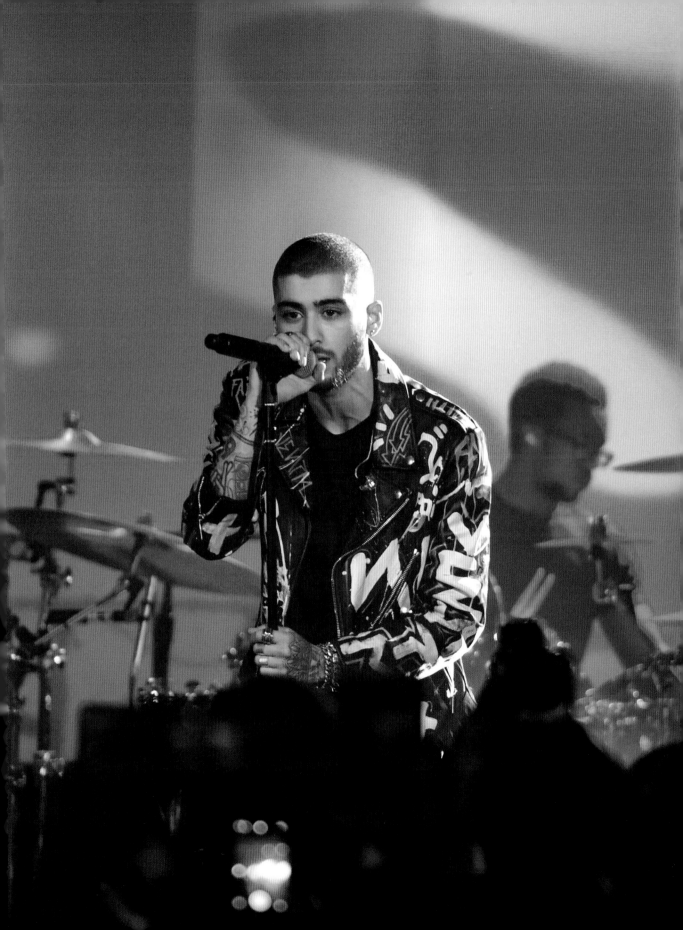

But there comes a point when it just doesn't work any more. By the time I finally made the decision to leave One Direction, it didn't even feel like a conscious decision. I just got to a point where I knew I couldn't go on. I was so tired. I felt like I was faking it, and I hated that. I just wanted to go home. Logically, it made no sense, leaving the biggest boy band in the world at the height of its success. But after nearly five years of non-stop touring and promotion. I was really struggling to keep going, and what had been a great experience was now a source of intense anxiety. It was never my intention to let anyone down. But I knew I had to go. I remember finishing a show in Hong Kong and just feeling it in my gut. To this day, it makes me feel like shit to think about disappointing the fans like that. But I hope they understand that I had to do what was right. Sometimes you just know it. My head said stay but my heart said go home. So, in the end, I went.

# 02.

# TIME FOR ME TO MOVE ON

'When I got home, I told everybody the same thing: that in leaving the band, I felt like a huge weight had been lifted from my shoulders.'

'I CAN'T UNDO SOME OF THE THINGS IN MY LIFE THAT HAVE NEGATIVELY AFFECTED ME, BUT I CAN PRACTISE BEING A BETTER PERSON, AND I THINK THAT'S A PRETTY DECENT PLACE TO START.'

The way I see it, life is a series of ups and downs for everyone, no matter who or where you are. Doesn't matter how rich or successful you are, there's no avoiding some of the bad parts of life: rejection, betrayal – all that. For me personally, I'm gradually learning to draw creative inspiration from emotional upheaval, and to try to have a sense of humour about it. I think getting stuff off my chest through writing music helps me to be a better person. I can't undo some of the things in my life that have negatively affected me, but I can practise being a better person, and I think that's a pretty decent place to start. As I walk that line between feeling like I'm doing the wrong thing for the right reasons, or the right thing for the wrong reasons, I'm getting better at using all of that experience to create my music. At least, I hope I am.

In that transitional phase between being in the band and being a solo artist, I've been very aware of how many people just know me as 'that one who left One Direction'. I hope that will change with time. I'm a guy who's always thinking about moving forward, what my legacy is going to be, what people will think of when they hear my name and my music. I think that's partly where a lot of my anxiety comes from. Half of me is just like, 'Fuck it, I don't care what other people think of me,' but the other half of me is the total opposite. That idea of legacy is really important to me. I want to leave my mark in a way that feels honest and authentic, I want to be known as somebody who isn't afraid to do what he wants to do, no matter what other people might say or think, and to do that I've got to be in control of my career.

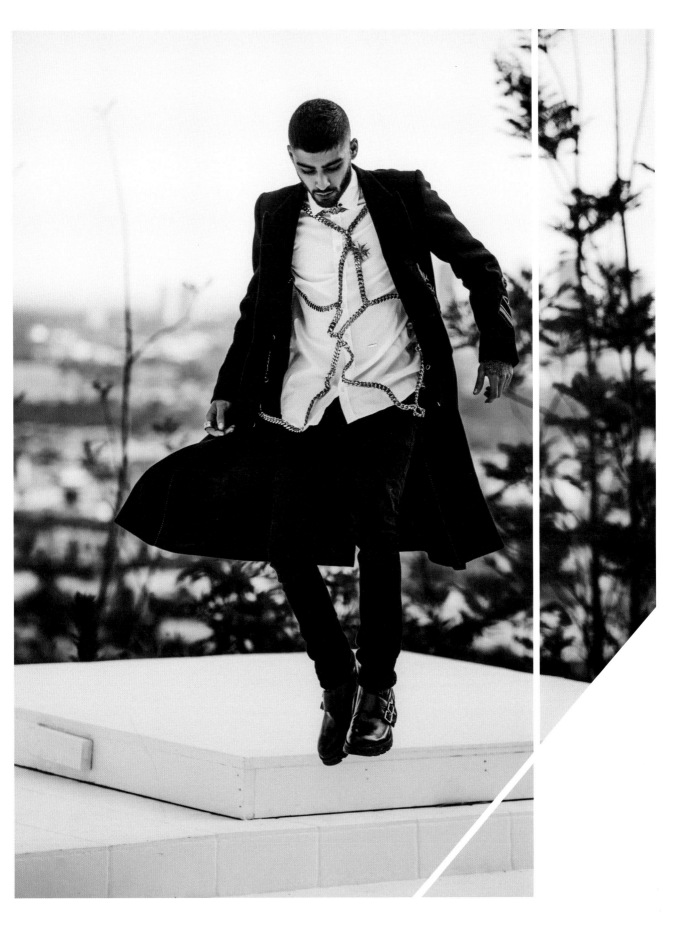

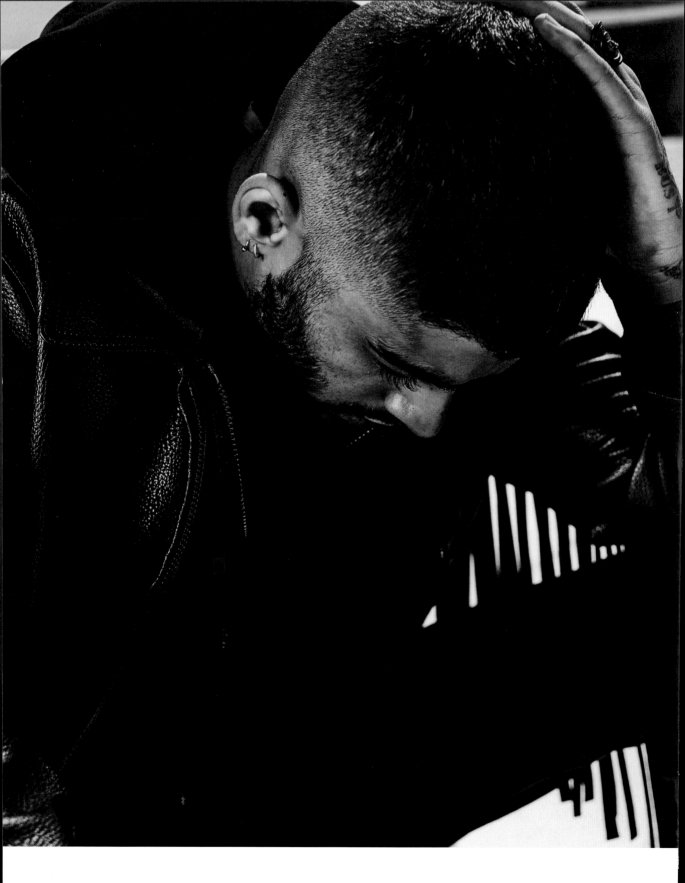

So now it's on me to prove myself as an artist in my own right. Which is pretty fucking crazy and scary all at once. Only time will tell how it's going to turn out. The good news is, I'm now in a much better place to take on that challenge than I was. Now that I've got the creative freedom to be a more authentic version of myself and to release the music that I want to make, I guess I have to leave it up to my fans to find the integrity in it. I'm putting my arse on the line by being one hundred per cent in control of the creative steering wheel, so to speak: from the creation of a song, through the stage design for performances, the album cover artwork, the sleeve notes, this book, *everything*. It's all coming from me and, hopefully, people will connect with that. It's a huge leap for me. Sometimes it feels like I'm exposing my soul and putting it out there for the whole world to judge. There's a new kind of pressure in that. It's not like the old pressure to conform, more like pressure to live up to my own expectations. It's amazing to see the fans from One Direction who are excited by my new musical path and have celebrated it with me, not to mention the new fans who've come on board.

Although the final step was quick, it took a long time to reach my decision to leave One Direction. It was like this tug of war between my head and my heart.

# MELTDOWN

It was March 2015. I had been in a bad place for a while and I didn't see myself getting out of it unless I made a change. My relationship with my fiancée, Perrie, was breaking down. To make matters worse, there were so many crazy stories flying around in the newspapers about us, and it felt like such an invasion of privacy, it made me just want to disappear for a while. It happened that night in Hong Kong: literally, while I was on-stage, I realized I wasn't going to do it any more. I wasn't going to spend another minute doing something which made me ill and which I no longer believed in. I couldn't see that there was anything left for me to give or to gain from staying. It wasn't worth it. The memory of that night is kind of a blur, I was in fucking bits, but I finally came to the realization of something I already knew deep down, and had known for a very long time: I was leaving the band and going home.

'WHEN YOU MAKE BIG DECISIONS IN LIFE, VALIDATION FROM YOUR FAMILY IS SUCH AN IMPORTANT FACTOR.'

My little cousin was on tour with me. We were sitting in my hotel bedroom together after the show, going over everything that had happened. He understood I'd had enough, that I wanted to get out. And he didn't argue me out of it. I respect that. When you make big decisions in life, validation from your family is such an important factor – especially when it comes to trusting the choices you've made. My mind was made up, but the deciding factor was an honest conversation with my parents. Obviously, my mum and dad were both kind of concerned that I was choosing to leave One Direction, but I was physically and mentally exhausted – beyond exhausted. I was spiralling down into a very unhappy, very unhealthy place. I needed to reconnect with my family and feel some normality again. And, finally, it was my mum who gave me the reassurance I needed to go with my decision. She said, 'If it doesn't make

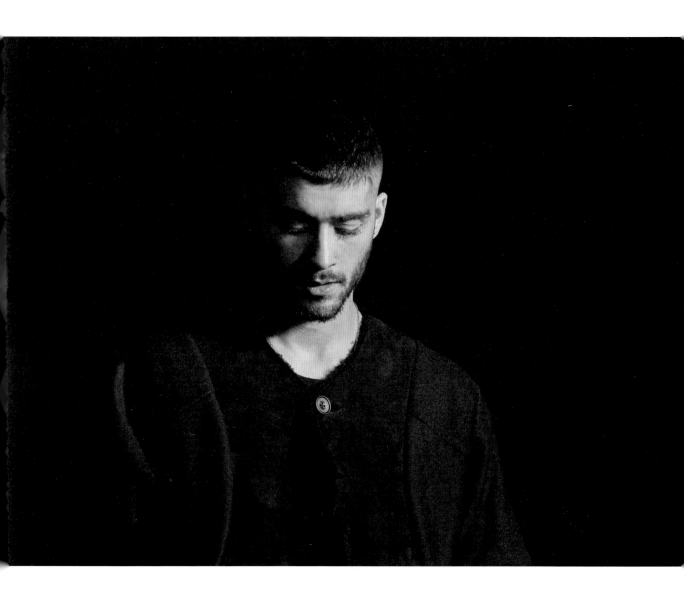

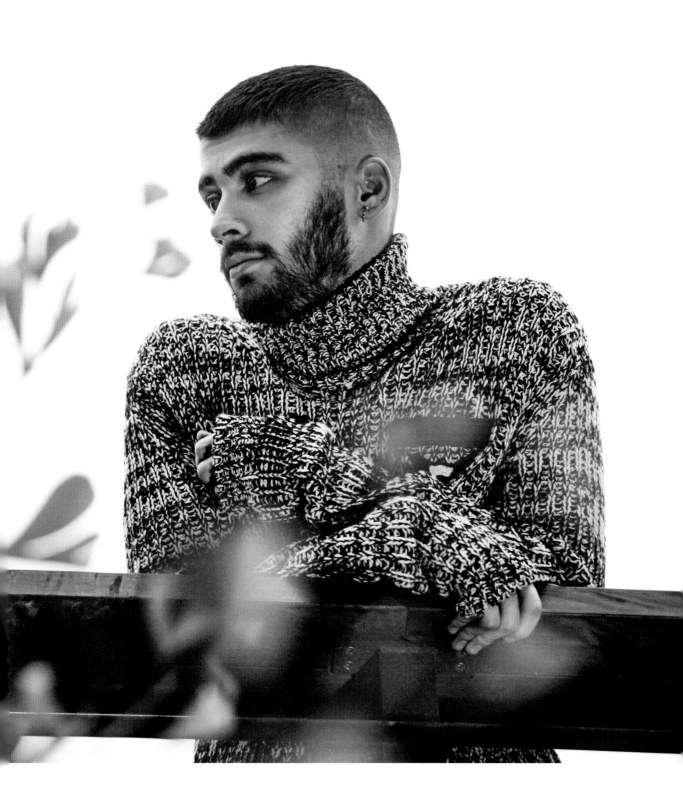

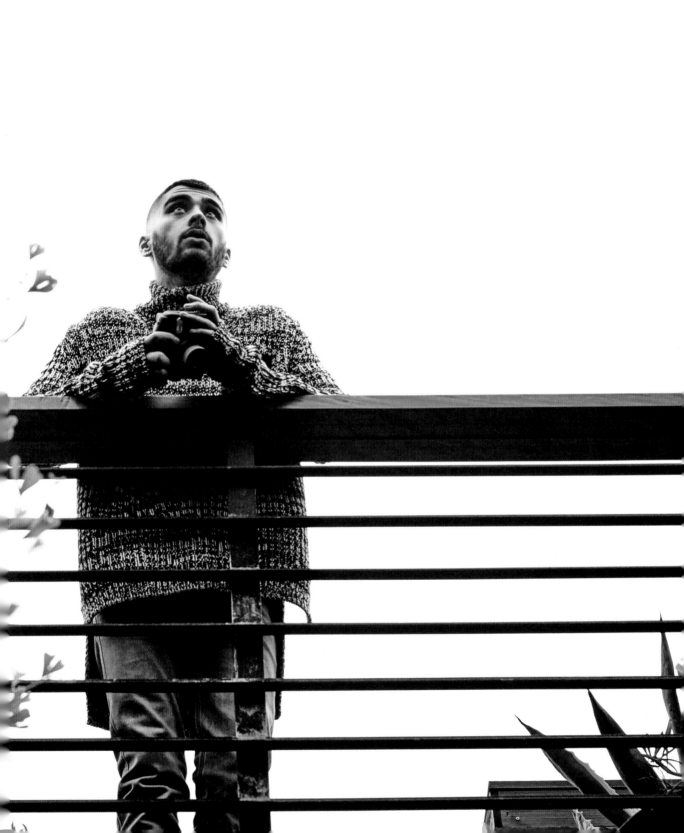

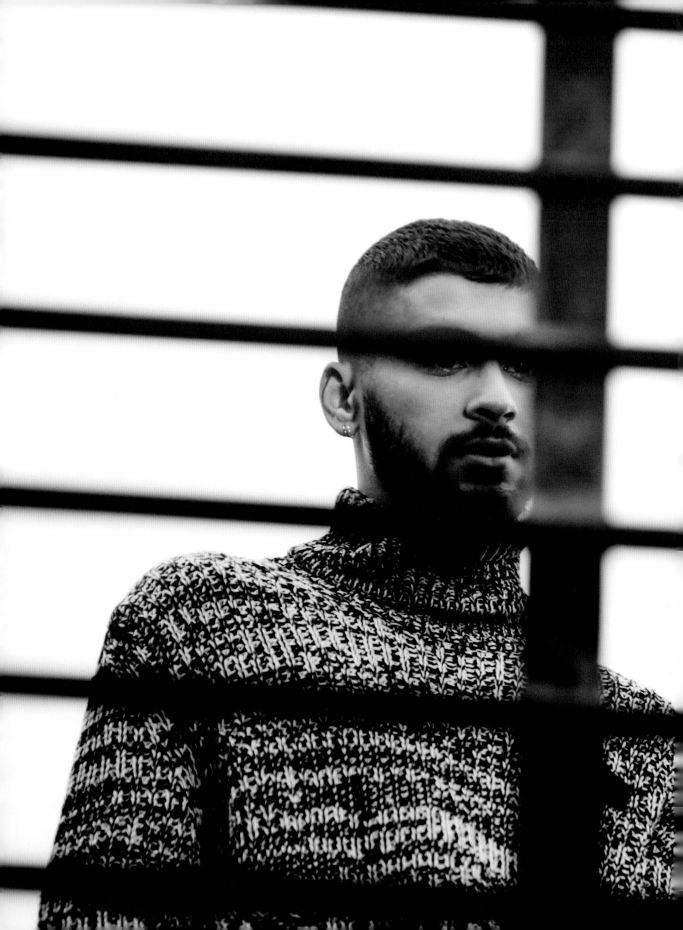

you happy, just don't do it.' That simple. I felt like that was the permission I needed to do what I needed to do. It reminded me that, at the end of the day, even if everyone else in the world hated me, my mum would always be there for me. I don't even care how cheesy that sounds! When I got home, I told everybody the same thing: that in leaving the band, I felt like a huge weight had been lifted from my shoulders.

At the back of my mind I knew this would upset a lot of One Direction's fans. I know a lot of people didn't see it coming. From the perspective of an outsider, these sorts of things aren't always obvious, especially when you can't see what's going on behind the scenes, so I know it came as a shock to many. But at that point, I just needed to look after myself. Not in a selfish way. It's just, sometimes, you have to do what's best for you, otherwise you're no use to anyone. Nothing good would have come from dragging it out any longer.

The first thing my mum did when I got home was cook me my favourite chicken curry. I had lost so much weight I had become ill. The workload and the pace of life on the road put together with the pressures and strains of everything going on within the band had badly affected my eating habits. Mum was a dinner lady when I was younger, and she's an amazing cook. In my humble opinion, her recipes are world class. She makes insanely good lasagna and homemade samosas, and her curries are her speciality, so it was good to get back to them and be reminded of the food I had eaten in my childhood.

As soon as I was back being comforted by the familiarity of home and family, I began to feel a bit better. I could just hang out, away from the press and the paparazzi. Back in London, it felt as though they were constantly on my back, but here in Bradford, I'd wander around the town in my dad's old sheepskin coat and not be bothered at all. I could go for late-night walks with my old mates, just messing around in the park, like any twenty-two-year-old. That privacy was really liberating. It was something I hadn't had in a long time. Being back home reminded me of what life was like before I auditioned on *X Factor*. Anonymity.

Normality. Peace and quiet. It was a good thing for me, having that change of pace and feeling normal again after those crazy, intense years when we never stopped.

This was the beginning of a big period of adjustment. I had a lot of time to reflect. On the one hand, I was starting to feel better, healthier, but I also felt this massive sense of isolation that goes with being lost. I'd stepped into a big unknown and I'd left a lot of colleagues behind. I did still have a couple of people, though. Shareena, who was my PA at the time and is now part of my management team, came with me and stuck by me even when I left the band, but for the most part all the people I had worked with so closely for five years were now on the other side of the fucking world — literally. It took some time, feeling very lonely, to get my head around this change. And then there were the fans I'd met, amazing people from all different walks of life. They had been as much a part of my experience as the boys and the crew, and I knew many of them by name. I didn't know if I'd ever have that life again, so saying goodbye to all of that was really tough. It was only after leaving that I finally had time to properly process everything that had happened to me since that first X Factor audition back in 2010.

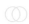

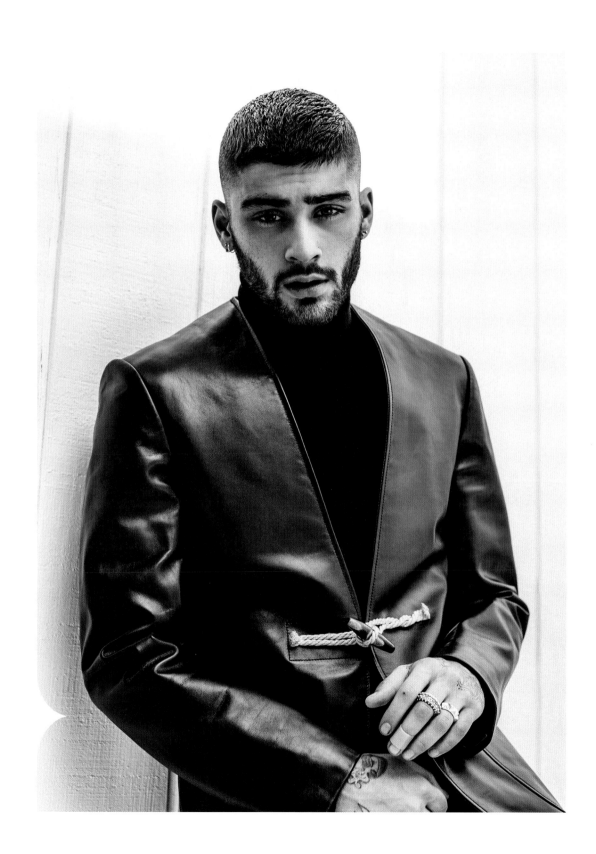

I probably would never have made it on to *X Factor* in the first place if it hadn't been for my mum. If I hadn't gone that day, who knows where I would have ended up. I was a bit of a lazy kid. I watched *X Factor* on the telly and always fancied having a go at it. But motivating myself to try out at the audition became a bit of a mission. I'd get the application forms, but then I'd never fill them in and send them off. My attitude was, 'Well, I'm never gonna get through, am I? So what's the point?' Even once I'd finally made up my mind to go, had managed to fill in and send off all the forms and been given a date for the audition, I still struggled to get to it. On the day, I just didn't want to get out of bed. Mum kept trying to coax me to get up, but I gave her the same excuse as before – that I didn't think I was going to get anywhere with it, so why bother? She told me I'd never know unless I tried.

It's kind of darkly ironic that that was my first experience of performing, me not wanting to go onstage and having to be coaxed into it. I always tell the story as if I was just being lazy, but actually I know deep down I was grappling with crippling nerves. That's something I've always struggled with. I was never that overconfident, performing kid who wants to sing for everyone. I'd sing in my bedroom, that was it. I did act as a kid, but that was different. I could play a character and escape behind that role. Singing was something else entirely. I'd never even sung in front of my parents properly before let alone

in front of an audience and TV cameras. I think my biggest motivation for doing it was the idea that it could – even though I never for a second thought it would – be a way of helping my family, making money for them, proving to them what they meant to me. The fact that my mum believed in me so much that day is the reason I am where I am now.

Skip forward nearly five years to me explaining to my parents that I was going to start a solo career and write my own material – stuff that was more personal to me, the music that I was into . . . well, their reaction was mixed, to say the least. My mum was as supportive as always – I'm pretty sure she believes in me no matter what I choose to do – but my dad not so much. He's not unsupportive, he's just a bit more of a realist, or whatever you want to call it. But that's been a good thing. He challenges me to go beyond myself. You need both those approaches to shape your character: being supported and being challenged.

'ONCE WE STARTED TO GET BIG, THERE WAS NOBODY WHO COULD HAVE PREPARED US FOR WHAT WAS GOING TO HAPPEN.'

'WHEN YOU'RE YOUNG, IT FEELS LIKE IT'S IMPORTANT TO FIT IN WITH WHAT EVERYONE ELSE IS DOING, BUT NOW I REALIZE THAT ME HOLDING BACK AND DOING DIFFERENT STUFF WERE JUST PARTS OF MY PERSONALITY – AND NO BAD THING.'

# FAMILY

My dad, Yaser, has always been massively into music and, when I was little, I think it was a bit of a mission of his to turn me on to nineties hip hop. He was always playing Biggie Smalls (aka The Notorious B.I.G.) and Tupac, who had a huge impact on me. My dad also introduced me to Prince, Bob Marley and Gregory Isaacs, artists who would also influence the work I did on *Mind of Mine*. I like to raid my dad's record collection and listen to all his stuff. His love for music rubbed off on me. It got into my blood really young.

I guess my dad's reaction to me going solo fired me up a little bit, in a positive way. I decided I had to show him I could make it, prove him wrong, I suppose, and luckily it worked. The first time he heard *Mind of Mine*, he texted me and said, 'Proud of you son.'

My parents' support was one of the reasons why, once I became successful with the band, I wanted to buy my family a house. It was a way of saying thank you for everything they'd done for me. I grew up without much but, even so, my parents had given me everything and I wanted to give them something back. And it wasn't just my parents. My whole family has always been a huge support.

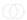

My grandma, Jean, was also a massive influence on me when I was younger. Sadly, she passed away in 2016. I miss her loads; she always had something to say about what I was doing. She was always very supportive and extremely proud of me. I'm so glad she got to see me at the peak of One Direction's success. I think the lyrical content of some of the tracks might have been a bit much for her sometimes, but she was always my rock.

# 'THAT WAS A HIGHLIGHT FOR ME, SHARING MY ONE DIRECTION EXPERIENCE WITH MY FAMILY AND MY EXTENDED FAMILY . . .'

When I was a kid, my grandma and granddad, Walter, ran a pub in the city. It was called the Bradford Arms and, as a tribute to them, I've built a boozer in my own back garden in London. I like to hang out there and have friends over. It doesn't look that special from the outside: basically, I just bought the biggest shed I could find from the local DIY superstore. It's sick. I've filled the place with all this memorabilia. I've got the same velvet curtains and Chesterfield sofa as my grandparents had back in the Bradford Arms. They even gave me the original sign from the pub. There are a couple of beer pumps and all sorts of random shit lying around. Whenever I'm in London, it's a bit of a safe haven for me. A home away from home and a solid reminder of my roots.

It wasn't just my parents and grandma who were a big influence on me when I was growing up. When I was young, I was usually surrounded by women. My aunts, or 'poppos', as I would call them, were like second mums to me. I was always going into one or other of their houses, just like it was my own, and my cousins were like siblings to me. Whenever One Direction played shows close to Bradford, the whole lot would come along. Three coaches would take them to wherever we were performing that night. They'd all be massively excited, this whole big tribe of them, and they'd take over a row of seats for themselves, maybe even more than one. It was pretty cool to be able to look over and see them all while I was singing up onstage with the band. They'd be cheering and dancing, just proper losing their minds. That was a highlight for me, sharing my One Direction experience with my family and my extended family . . . and my extended extended family.

# GROWING UP

Growing up in Bradford, I always knew I wanted to do something creative, but it took me ages to figure out what I'd do and how I'd do it, and because I was really shit at expressing myself in a way that I wanted to as a kid, I'd often act out. I was pretty wild. I could never focus, couldn't get a handle on where my brain wanted to go. I was constantly getting into trouble. Once, when I was at Tong High School, I was collared for having a BB gun in class. It wasn't loaded or anything, but me waving it around didn't go down too well. A few teachers have come out recently and described me as being a 'model pupil', but I saw it differently at the time. I was just a nerdy kid desperate for a creative outlet.

I was later diagnosed by doctors as having super-hyperactivity – or ADHD (Attention Deficit Hyperactivity Disorder), as they like to label it. I think there's an infinite spectrum of behaviour in human beings. Labelling a kid ADHD, or whatever, can help identify solutions for some, but it can have a negative effect on others. With hindsight, I think my hyperactive-type personality stemmed from the fact that I couldn't find anything creative to get passionate about. All that energy was getting bottled up, and then I would just reach tipping point and explode. That's part of why I think boxing was, and still is, so important to me.

I always loved boxing when I was a kid. It was something that my dad and I were both into. The only time I was ever allowed to stay up really late was when there was a big fight on the telly. I was so mesmerized by all the bright lights and the glamour of those title fights in Vegas or at Madison Square Gardens. It was something me and my dad could enjoy doing together. It was our thing. Father–son bonding and all that.

Time for me to move on

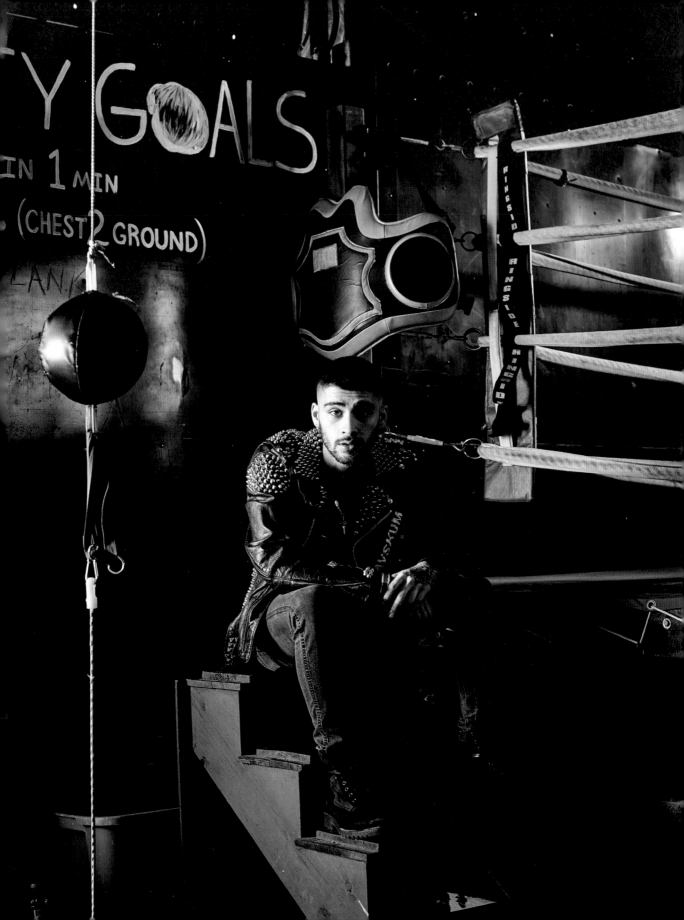

Once I got to around fifteen, I started putting a bit of weight on. I got kind of chubby – nothing major, but enough that I wasn't too happy about the situation. That's when I thought, 'Right, man, I'm gonna get into the gym and train.' But just working out in a gym seemed boring to me, so I decided to give boxing a go. And once I'd started doing it myself, I loved it even more.

Before I started boxing, I'd been quite into sports, but I was never that much of a fanatic, not compared to a lot of the lads where I grew up. I did have a season ticket to Bradford City FC, but I wasn't really into football – not playing it, anyway. I basically used to go because it meant I got to hang out with my granddad. He was a big fan. I was more into cricket, and eventually I became an all right bowler, but that wasn't a sport that was going to get me back into shape.

I started out boxing at Bradford Police Club. My trainer there was amazing, a really cool guy. After about a year and a half, I'd worked so hard that I developed a bit of a six-pack. Now that I'd toned up and toughened up, my dad and my uncle couldn't say shit. But boxing didn't just change me physically. It shifted my mental attitude as well, and there were some lessons learned along the way. Ironically, I think the most important lesson of all was that I was taught how *not* to fight. I learned a lot of discipline. Before I started at Bradford Police Club, so before I got into my mid-teens, I acted pretty dumb. I watched how people behaved on the TV, the way they lashed out whenever somebody did something they didn't like, and I believed all that shit. I thought, 'Yeah, this is how men behave.' Whenever I got into a bit of a confrontation, I would lash out and fight back.

Recently, I went into the Trinity Boxing Club in LA for a photo shoot. It was a crazy, intense gym, full of serious fighters. Being there really reminded me of those early days at Bradford Police Club. One of the first things I noticed when I walked in were all these motivational posters hanging around the place. Shit like: 'To appreciate heaven well, 'tis good for a man to have some fifteen minutes of hell' – that was a quote from Will Carleton, an American poet. And there was one from Mike Tyson that really struck a chord with me: 'Everyone's got a game plan till they get punched in the face.' I laughed when I read it, because it's so fucking true.

Something else that really helped me at school and made a difference to my behaviour was drama. When I was twelve or thirteen, I started doing theatre studies, and I found a lot of peace in acting – it was amazing and I loved it. I got so into it that I landed the role of Danny Zuko in the school production of *Grease*. Drama really helped me to express myself; it gave me an outlet. Weirdly, playing other characters made me learn more about my own personality, made me a bit more self-aware.

Self-awareness was definitely not something I'd had as a kid. When I was around the age of eight or nine I joined the school choir, basically because I thought it would help me to meet girls. Sometimes I would record songs I'd written at home on tape. One time I wrote and sang a couple of songs for a girl I quite fancied. I recorded them and left the tape in her locker at lunchtime. I prayed and prayed she would like them. No comment. Looking back, I guess they were pretty fucking embarrassing. I hope she's thrown that tape in the bin rather than kept hold of the songs. I'm not sure I'd like to see them pop up online.

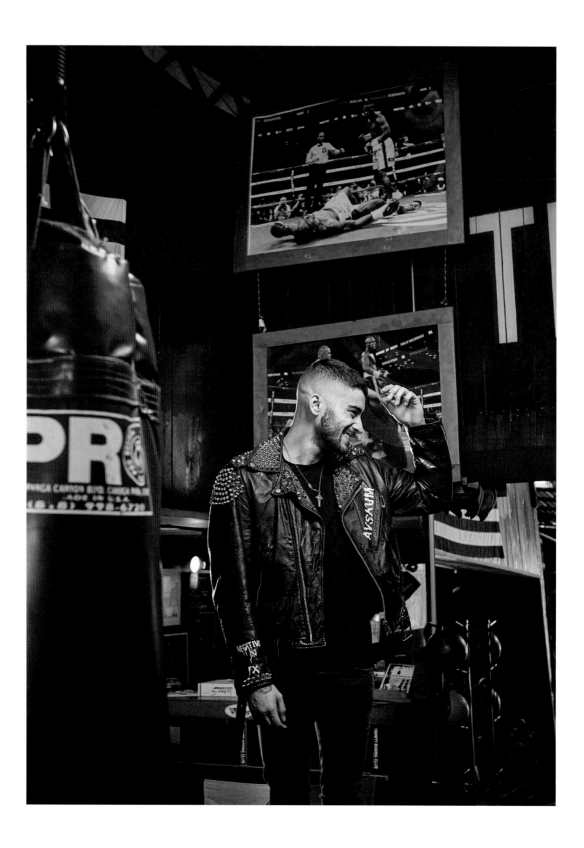

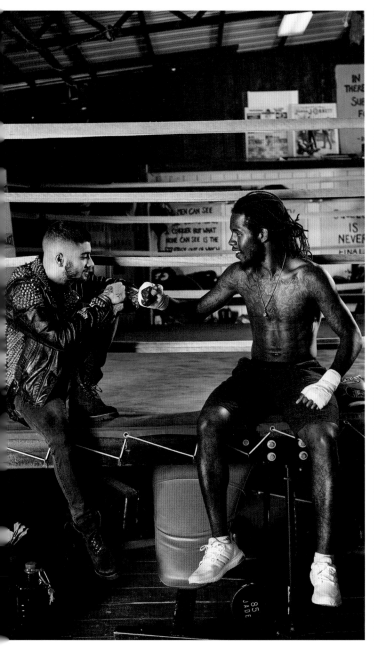

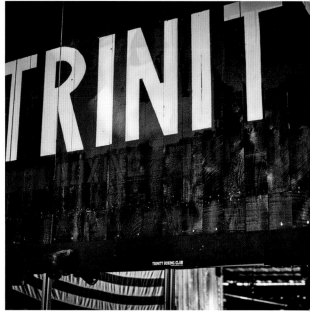

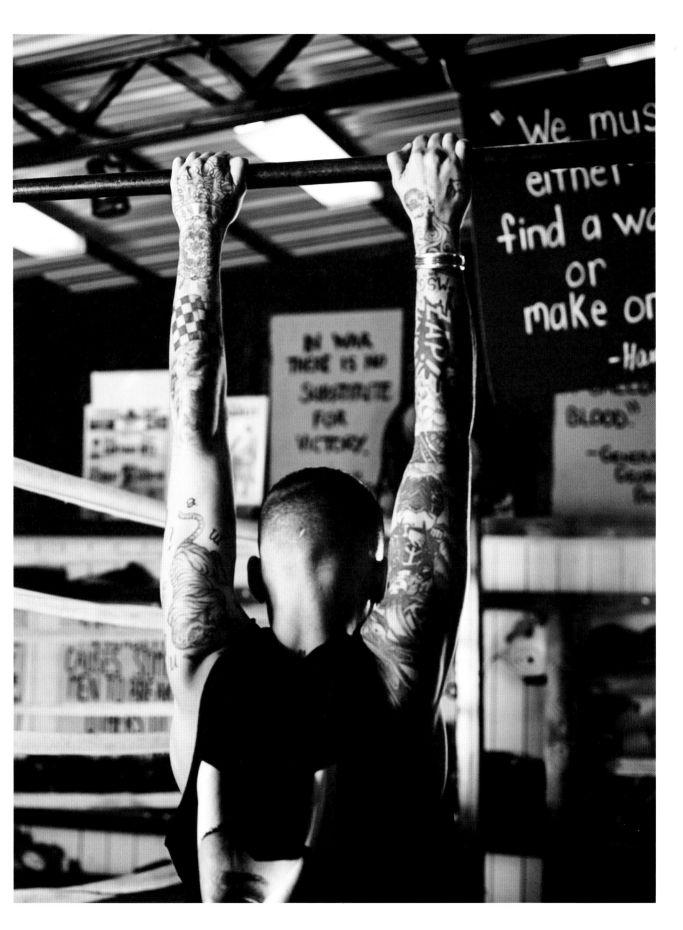

# BRADFORD

Bradford was my home, but it was also somewhere that made me dream big and want to get out. On the one hand, it was like a security blanket – family, friends, familiarity – but on the other it was a city where I often felt I didn't quite fit in. That aspect of it was tough at times. I'm mixed race, and when I was younger and kids gave me shit about my heritage, I would get pissed off and angry, lash out and fight. Over time, being from a multi-ethnic background became something I was proud of. It taught me the importance of accepting people for who they are, no matter what their background. My mum, Trisha, who is Irish by descent, only became a Muslim once she met my dad, and even though it wasn't something she'd grown up with herself, she made sure we all learned about the faith. She was so committed to it that she worked as a halal chef in a school near to where we lived. I think I must have read the Quran three times growing up, thanks to her. She also made sure we went to the mosque at weekends.

Bradford gave me the strength of character that has got me where I am today. The area where I grew up wasn't in the best shape, and there wasn't a lot for kids and teenagers to do. We were proud of our city, even though some of it was a bit run-down, so to improve it, we had to get creative, and that took character. There was a lot of defiance. People used their determination as fuel. If you don't have a bit of grit and determination and you live somewhere like that, you're not going to get very far. And that was as true for me as it was for everybody else. Developing that sense of resilience helped me deal with some of the press and the criticism that came my way later on in life. As a result, I reckon I've managed to keep pretty level-headed about some of the shit

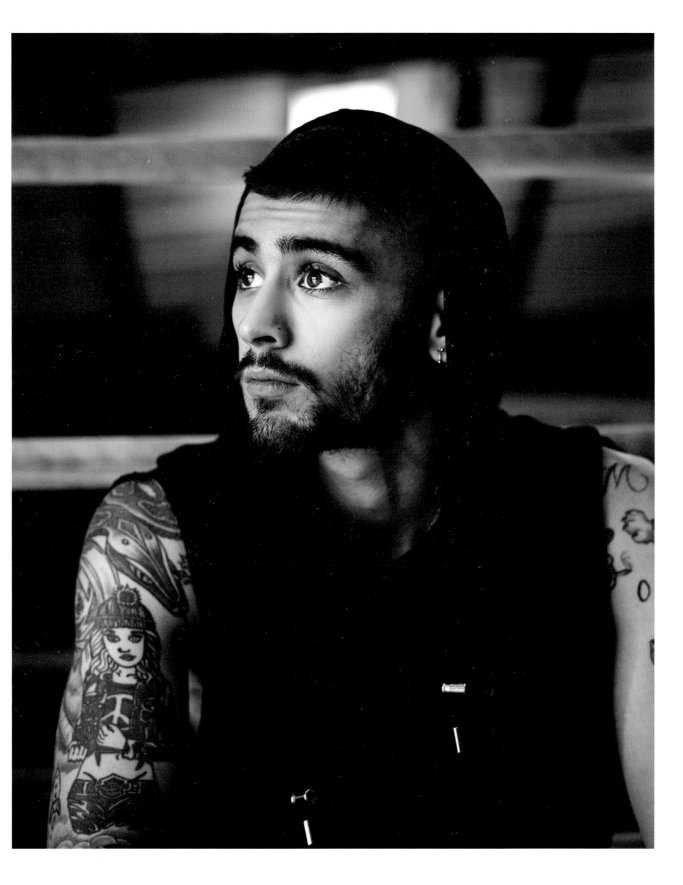

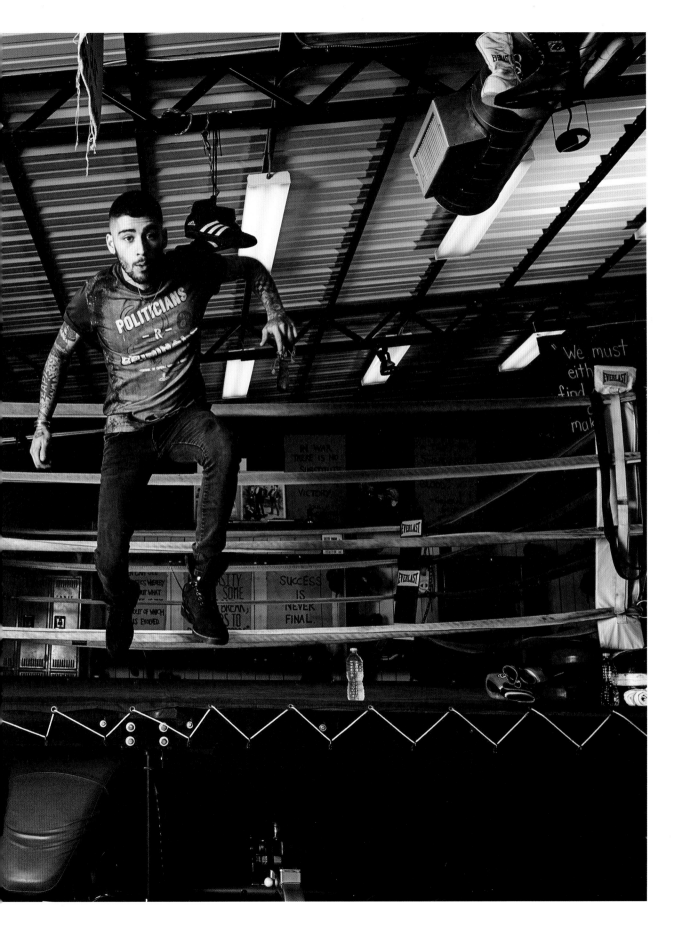

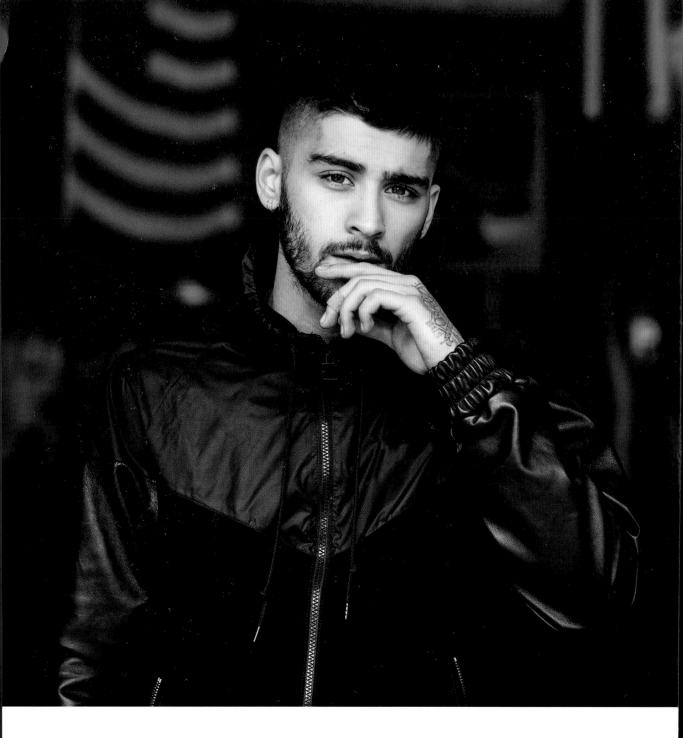

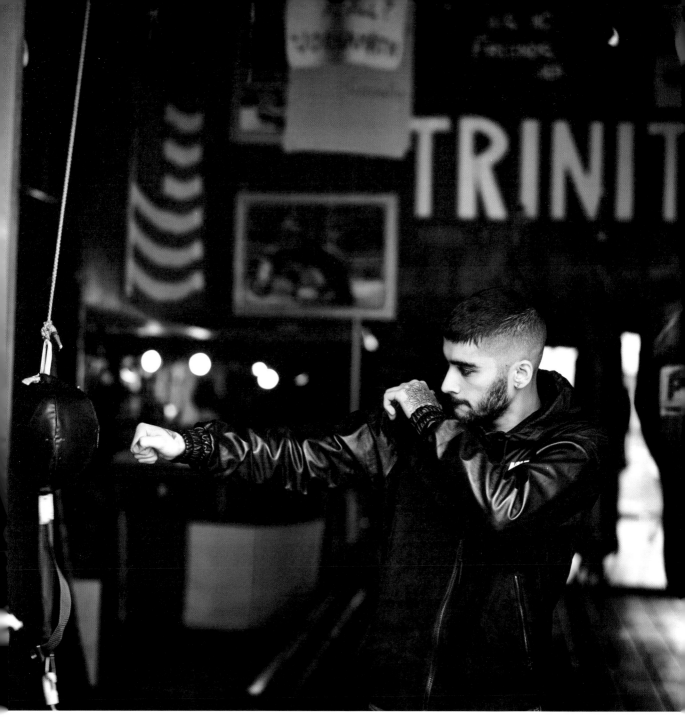

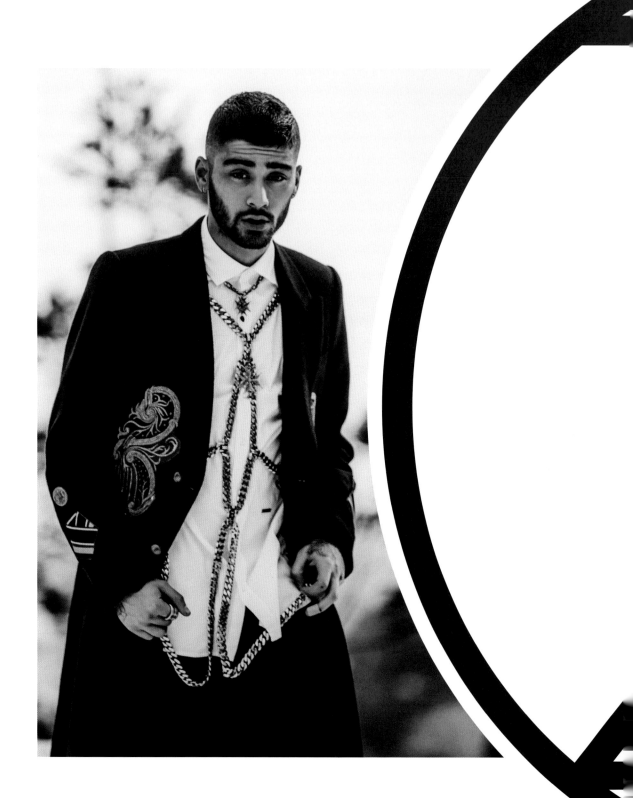

'I'M PROUD OF MY BELIEFS,
OF THE WAY I LIVE MY LIFE.'

that being in the public eye brings. Mostly, I couldn't give a shit if somebody writes something nasty about me. The only thing that really pisses me off is if somebody 'quotes' me when it's something I definitely didn't say. If what I say is deliberately misconstrued, or if something I've said is taken out of context, then I'm a bit like, 'That's not what I said.' That's when I get upset. It means I'm being falsely portrayed, and that's not something I'm OK with. Fuck that.

I'd like to think that a defiant attitude is a defining feature of my personality, but at the same time, if people try to rile me up by saying nasty things, I just don't rise to it any more, even if it's something racially prejudiced or a slight on my religion or my family. I don't want to stoop to the level of anyone who's giving me grief. I'm proud of my beliefs, of the way I live my life. My mum and dad have taught me well in that respect. They gave me a firm foundation for learning how to be a good and tolerant person.

My parents get that I'm into different things than they were when they were younger. I don't think they like all the tattoos I have, but they don't go on about them — they just let me get on with it. As long as I'm looking after myself and not doing anything stupid, they're happy. They've always been supportive and, at the same time, they've allowed me to live my life in the way that I want to live it. The only time they ever stress is when they think I'm not eating enough.

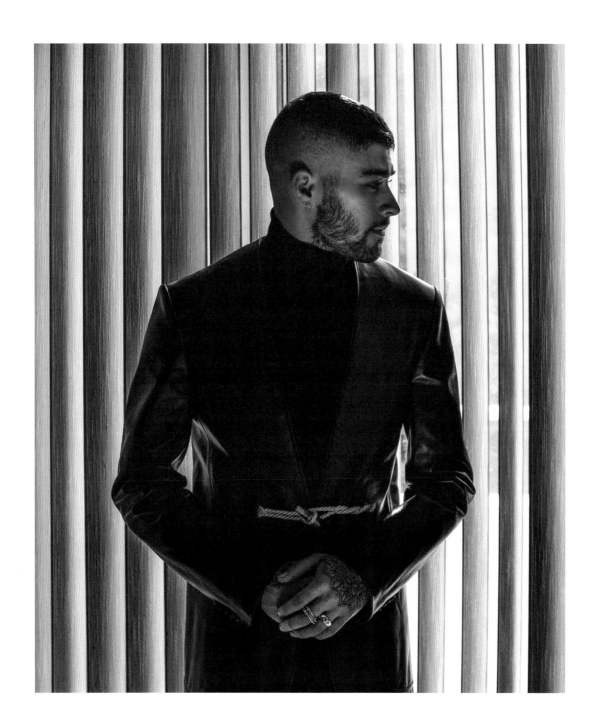

# FROM BRADFORD TO LA

Once I'd had some down time back home, reconnecting with my family and just generally trying to figure shit out, I decided I needed a change. I wanted to switch things up, gain some new inspiration. This was at a time when a lot of stuff was going on in my personal life. My engagement to Perrie was over. Because of that, and me leaving One Direction, the media in London was tailing me wherever I went. There were photographers parked outside my house all the time, and fans would ring the doorbell in the middle of the night. It all just felt like too much to take. I needed a change of scene. So I ended up in LA. I've been living here for the past year now, first at some rental houses which I got chucked out of for playing music too loud, then at the Beverly Hills Hotel, where a lot of *Mind of Mine* was written and a lot of room-service chicken wings were consumed – seriously, they're like the greatest thing ever; I still order them to my house now – and then in my own place in Bel Air.

LA was exactly what I needed. There's a nice vibe and I don't get hassled anywhere near as much as I do in London. If I come up with an idea, even if it's in the small hours, I can just call someone up to work with me and go to the studio to lay down some tracks. When I was younger, if somebody had told me that I'd be doing stuff like that, living the life of a recording artist in LA, I wouldn't have believed them. It's mad. From Bradford to Los Angeles. Who'd have thought it?

WHEN THE SMOKE IS
a cloud
Do you think
theres a cap
on the ceiling
seeing, belong the
feeling.

# 03.

# GONE FOR EVERY SONG

'For me, it was all about enjoying being able to mess around and do my thing. For the first time, I was totally in control of everything that was going on around me.'

# MYKL

During the spring of 2015, I started hanging around with the producer Shahid Kahn (aka Naughty Boy), and via him I also got to know a producer-duo of brothers called Mike and Ant Hannides (aka MYKL). I met Mike first and we really hit it off. To begin with we didn't even talk about music, we chatted about our exercise and food regimes. Both Mike and his brother Ant are mad into fitness. Aside from music, they spend a lot of their time competing as MMA (Mixed Martial Arts) fighters and usually train every day. It was only after talking about that that we got on to discussing our music. Mike explained to me all about MYKL and their background: that they had worked with McLean, Alesha Dixon, J. Sean and Rick Ross. I told them I had some ideas of my own, stuff that was very different to anything One Direction had done in the past. And that's when Mike invited me to his studio.

'Come over and check out what we're doing,' he said. 'We'll play you some tunes . . .'

I felt pretty pumped about it. At the very least, I thought I might get some fresh ideas out of it. So a couple of days later I went to F-Block at Ealing Studios, where they were working. They played a couple of their own tracks, which were R&B in style and totally what I was into.

Not long afterwards we were making tracks together. The process was sick. I would start with a lyric, something I'd written down in a notebook I always carried, and Mike would work up a melody on the piano. Once we had found a hook we liked, Ant and myself would go into the vocal booth and start putting down harmonies. Everything kind of fell into place, it felt really fluid, and it was in that way that we got down the outlines of several songs that would end up being on the *Mind of Mine* track list – 'Pillowtalk', 'Borderz', 'TIO', 'She' and 'Drunk'. We seemed to be on the same wavelength. I figured, 'You know what? With guys like this around me, maybe I really can make an album for myself . . .' It was beginning to feel like it might be something I could do.

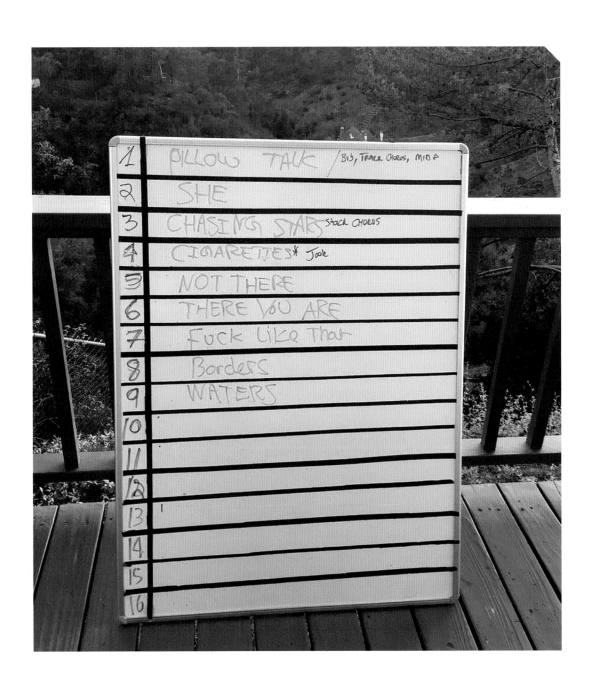

'EVERY LYRIC I'VE EVER WRITTEN

HAS A STORY BEHIND IT.'

# ⏱ SONG NOTES
# 'PILLOWTALK'

Every lyric I've ever written has a story behind it. All the hard work that went into the creation of 'Pillowtalk' was worthwhile because, as soon as it was finished, I intuitively felt I was on the right path. It was a sick cut, nailing the exact sound I wanted to capture in my music. I was also able to sing about a subject that I hadn't really been able to go near while I was in One Direction: sex.

One Direction's lyrics were pretty inoffensive. As I started to mature as an artist, I didn't want any topic to be off limits. The lyrics in 'Pillowtalk' are honest and undiluted: '*A place that is so pure, so dirty and raw / Be in the bed all day, bed all day, bed all day / Fucking in, fighting on / It's our paradise and it's our war zone.*' Let's be honest, I'd never have got away with writing, let alone singing, lyrics like that in One Direction.

When I wrote 'Pillowtalk', all the feelings I poured into that song came from genuine experience. That was really important to me. I wanted to sing stuff that I could feel, to be authentic and to transmit raw emotion through my vocals. People can see through artists who bullshit, and I hate it when I listen to songs and don't believe the person singing the lyrics. There's a strength in honesty, and it felt pretty amazing when my vocals came through more forcefully because I believed in the words I was singing. I hope whoever listens to the song gets that too.

'Pillowtalk' isn't just about sex; it's more layered than that. It's about the ups and downs of relationships. Good times and bad times. We're all tested in relationships – with our families, friends, lovers, whoever – and I like to think that, as I let go of some of the not so loving sides of myself, I encourage those I'm in relationships with to do the same.

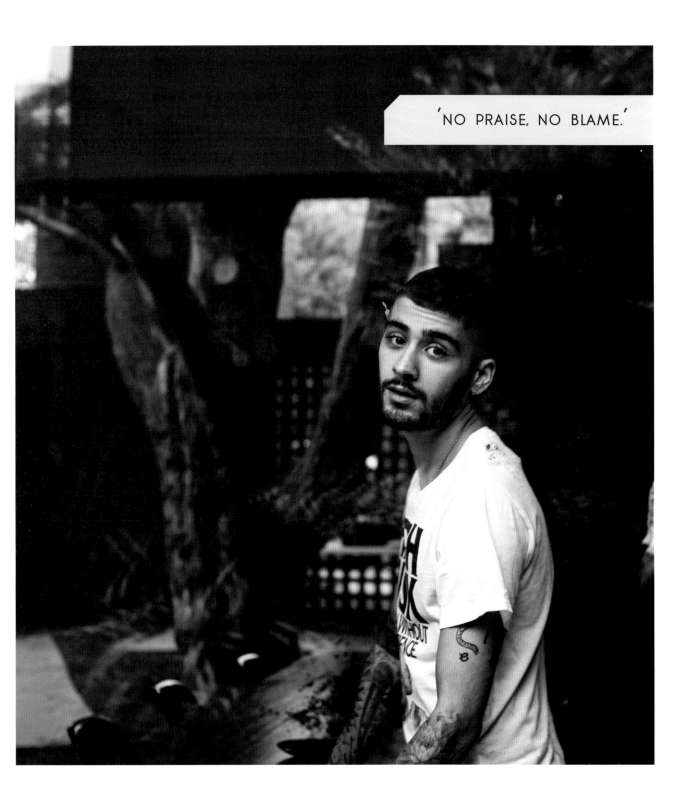

'NO PRAISE, NO BLAME.'

# MOVING TO LA

Around the time I met the Hannides, I was heading out to LA to look for a new place, and I was eager to cut some more tracks while I was there, so I invited them along for the trip, as well as my cousin Jawaad. We started off in a futuristic modern house in the Hollywood Hills, but got kicked out after multiple noise complaints. Then we moved to an even bigger house in Malibu where we had a massive BBQ party. That was my first party in LA and we got kicked out of the house when that party got a little rowdy, so we moved again, this time into a studio house in Bel Air that's owned by a huge record producer, Trevor Horn. This felt like my first real home in LA. Before long, we had locked ourselves into a routine. Every morning we would get up at nine, eat breakfast and then get into the gym. Ant and Mike would put me through a brutal workout. They're both the kind who drink four protein shakes a day. Each day we would work on two or three body parts: chest, triceps, calves, back, abs, quads. After a week, we'd worked through my whole body and every part of me had been pushed to the limit.

We'd do circuit training, too. Somebody would be on the treadmill while the other two boxed, then we'd switch around. I remember Ant lifting his pads up one morning and ordering me to smash him in the stomach for ten minutes. Some days we'd run up and down the hill carrying weights. It was like being on a proper boot camp. I loved it.

Then in the afternoon, we'd go into the studio, finishing off vocal takes and getting beats down, sometimes working late into the night. Other nights we'd go out. We'd go everywhere, to Hyde, Warwick, One Oak, Bootsy Bellows and Nice Guys. But we weren't just going out to get trashed. Promise. We were checking out the scene to see what was going on, what new music people were listening to. It was great to hear what the vibe was and how people were reacting to stuff. We liked to think of it as research, like us doing our homework. But I'm not going to lie, we had our fun, too; it was always a sick night. It really felt like life was looking up.

# ⊘ SONG NOTES
## 'DRUNK'

The song is pretty straightforward, especially the lines *'Right now I can't see straight / Intoxicated, it's true / When I'm with you / I'm buzzing and I feel laced / I'm coming from a different phase when I'm with you . . .'*

The idea for that song came about when I was working with the Hannides and one of them was telling me he'd just been to a music festival where everybody had got wasted. I wanted to take that vibe into a more downtime space, and 'Drunk' became a song for home, but inspired by what happens when you go out.

# XYZ

Shortly after finishing work with Mike and Ant, I linked up with 'mystery producer' XYZ. Of course, XYZ wasn't a mystery to me. I had known one of the guys, Alex, for ages – he was an assistant engineer for us on One Direction. He was the one who recorded our vocals when we were making albums on tour, and being on tour was always a pretty gruelling time. Because we were doing so many shows a year, we just didn't have time to work in a studio for several months to put down an album. Instead, we would walk off stage and, rather than us all going out, Alex would come around to our rooms to work on vocal tracks. He followed us everywhere – the US, South America, Asia – setting up makeshift studios in our hotel rooms. Alex is a cool guy. It was nice to reconnect with him and be recording together again.

We made some space in my home studio. It wasn't the full deal, but it was great for me to have somewhere I could work in my house. I had a mic there, plus a Gibson guitar, and Alex set up his recording unit in a large, office-type room – just a laptop and some equipment – in between all the paintball guns and pirate flags that were lying around. He would play all these amazing riffs on the keyboards. One of them was a kind of funk-style seventies groove, and I latched on to it straight away. Once we'd finished playing about with it and Alex had gone home after the session, I ended up messing around with the melody. I could tell it was really starting to take shape, and I found that I was enjoying the studio process more than ever. I definitely write and work better in a contained environment with a more intimate, smaller crew. Being surrounded by an entourage or a large crowd was never my thing, so working one on one with XYZ, or with a duo like Mike and Ant, felt more natural. The studio became a safe place for me. I was free to be whoever I wanted to be. And I was in fucking LA, of all places. It was dope.

'THE STUDIO BECAME A SAFE PLACE FOR ME. I WAS FREE TO BE WHOEVER I WANTED TO BE.'

## ◍ SONG NOTES
# 'FOOL FOR YOU'

The song 'Fool for You' started in that home studio. It was a bit in the mould of a classic Stevie Wonder song. Later, I worked on the track on my own and came up with the lyrics '*This love is tainted / I need you and I hate it / You're caught between a dream / And a movie scene / In a way, you know what I mean . . .*'

All in all, it took around eight months to finish that one track, but, as far as I was concerned, it was worth it: I was proud that I'd written it pretty much by myself. I'd been listening to a lot of tracks by the Beatles when I was working on it. I had really got into some of their more psychedelic stuff, like 'Lucy in the Sky with Diamonds' from the 1967 album *Sergeant Pepper's Lonely Hearts Club Band*. The piano chords at the start of 'Fool for You', and the guitars, were inspired by the Beatles' sound. That might strike some fans as weird, but I like to draw on the influence of all sorts of music and artists.

# STUDIO VIBES
# MYKL ON ZAYN

We knew Zayn could go all the way as a solo artist as soon as we met him. The guy's a superstar and, as producers, we're always on the lookout for people like him. It's quite rare to find someone with his talent — it's hard for a writer or a producer to find what Zayn has. As soon as we met him, the pair of us knew we could do something incredible.

Zayn had a vision for the music he wanted to make. It was quite clear, almost from the minute we first met him, that the music he listened to and grew up on was exactly the same as the stuff that had influenced us — R&B, hip hop, Prince, Michael Jackson — tunes that we were still listening to and loved. But there were no rules. When it comes to making music, Zayn doesn't conform. It was very creative and all of us were very open with the way we were going to work. Everything was loose and expressive.

We didn't see that coming when we first met Zayn. We knew he was a star, but didn't realize he was so . . . *super-talented*. We hadn't seen the creative side of him and what he could do in the studio. But when we did, it just blew us away. Zayn is a 'creative', an artist. He lives to be expressive. Wherever he is now, he'll be doing just that — writing, recording, creating something. He loves to push the boundaries of what's possible and do things that no one else is thinking of. There are literally no limits to what he can achieve.

We knew he was happy making music — he wouldn't be doing it otherwise — but we didn't realize just how happy until we saw him after the release of *Mind of Mine*. Me and Mike travelled to LA to hang with him just after the album had come out. It had gone to number one and he was delighted. I said to him, 'Bro, you look so happy.' And he started laughing. 'I am!' he said. 'This is just my dream . . .'

## ⊹ STUDIO VIBES
# XYZ (ALEX ORIET) ON ZAYN

I first got working with Zayn when he was in One Direction. It was my job to get their vocals down whenever they were on tour; because they were so busy that was the only time for them to get their albums recorded. I would have a laptop and a good mic, and it was up to me to wake them up and get them to sing.

Think about it: they were performing in front of sixty thousand people and then having to go back to a hotel room and sing a new song to one person — me. That wouldn't have been the most exciting thing in the world for them. After a big show, it's natural for an artist to want to let loose, have a drink and decompress.

Once I started working with Zayn again on *Mind of Mine*, I got to see him as a songwriter. He was honest and unaffected; I think he likes to take his time, and he's definitely one of those people who likes to record with as few people around him as possible. He's not one for having an entourage, which is good, because it adds a sense of mystery and magic to what he's doing. Studio life is quite a safe place for him — it keeps him protected. Maybe that's a hangover from the days of One Direction. It gives him some quiet time, some sanctuary.

In terms of energy, he's a completely different Zayn.

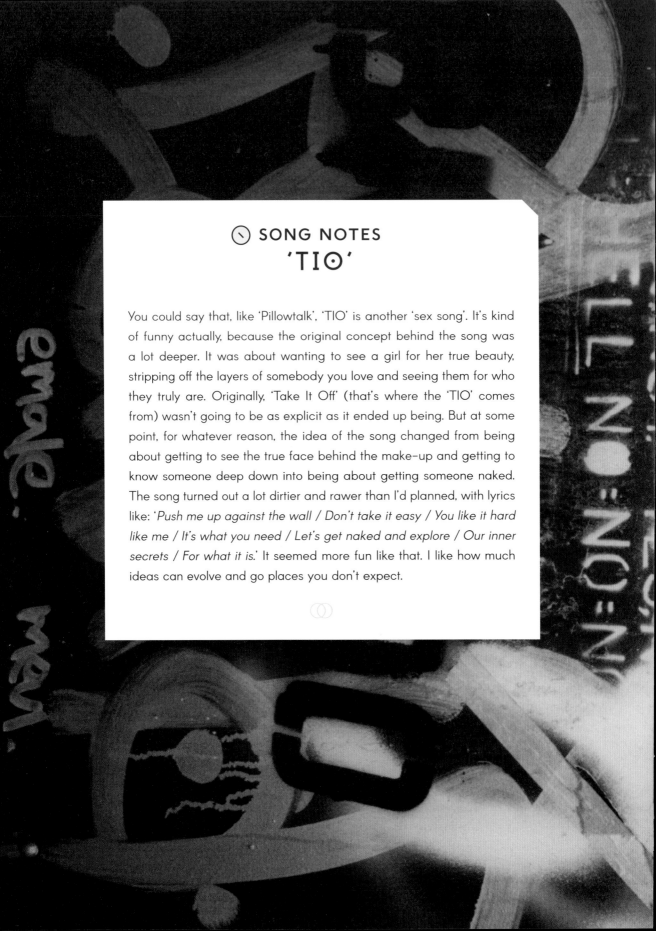

# ⊙ SONG NOTES
## 'TIO'

You could say that, like 'Pillowtalk', 'TIO' is another 'sex song'. It's kind of funny actually, because the original concept behind the song was a lot deeper. It was about wanting to see a girl for her true beauty, stripping off the layers of somebody you love and seeing them for who they truly are. Originally, 'Take It Off' (that's where the 'TIO' comes from) wasn't going to be as explicit as it ended up being. But at some point, for whatever reason, the idea of the song changed from being about getting to see the true face behind the make-up and getting to know someone deep down into being about getting someone naked. The song turned out a lot dirtier and rawer than I'd planned, with lyrics like: '*Push me up against the wall / Don't take it easy / You like it hard like me / It's what you need / Let's get naked and explore / Our inner secrets / For what it is.*' It seemed more fun like that. I like how much ideas can evolve and go places you don't expect.

## □ POLAROID
# EMBROIDERED VELVET COAT

I love this coat. I've always had a bit of an individual style, even when I was a kid – for real. I hated school uniform, and all the rules, having to wear a tie and shit. But when I sussed out that there were no rules regarding how we wore our school blazers, I would walk around the place with one arm in a sleeve, the other out, with my jacket dangling over a shoulder. But then being so much in the public eye at a young age, I got a bit nervous to take many risks. I wasn't so keen to step outside my comfort zone or think outside the box on what I was wearing. It was a great moment for me when Donatella Versace invited me to attend the Met Gala with Versace. I'd definitely made a conscious decision in my solo career to take fashion more seriously, starting with attending two shows in 2015 with Louis Vuitton and Valentino.

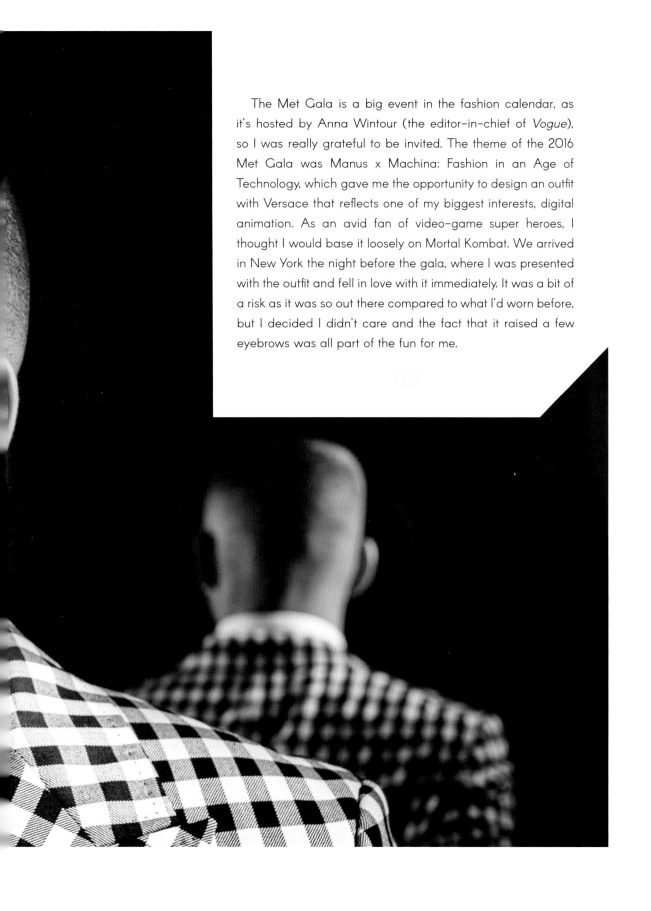

The Met Gala is a big event in the fashion calendar, as it's hosted by Anna Wintour (the editor-in-chief of *Vogue*), so I was really grateful to be invited. The theme of the 2016 Met Gala was Manus x Machina: Fashion in an Age of Technology, which gave me the opportunity to design an outfit with Versace that reflects one of my biggest interests, digital animation. As an avid fan of video-game super heroes, I thought I would base it loosely on Mortal Kombat. We arrived in New York the night before the gala, where I was presented with the outfit and fell in love with it immediately. It was a bit of a risk as it was so out there compared to what I'd worn before, but I decided I didn't care and the fact that it raised a few eyebrows was all part of the fun for me.

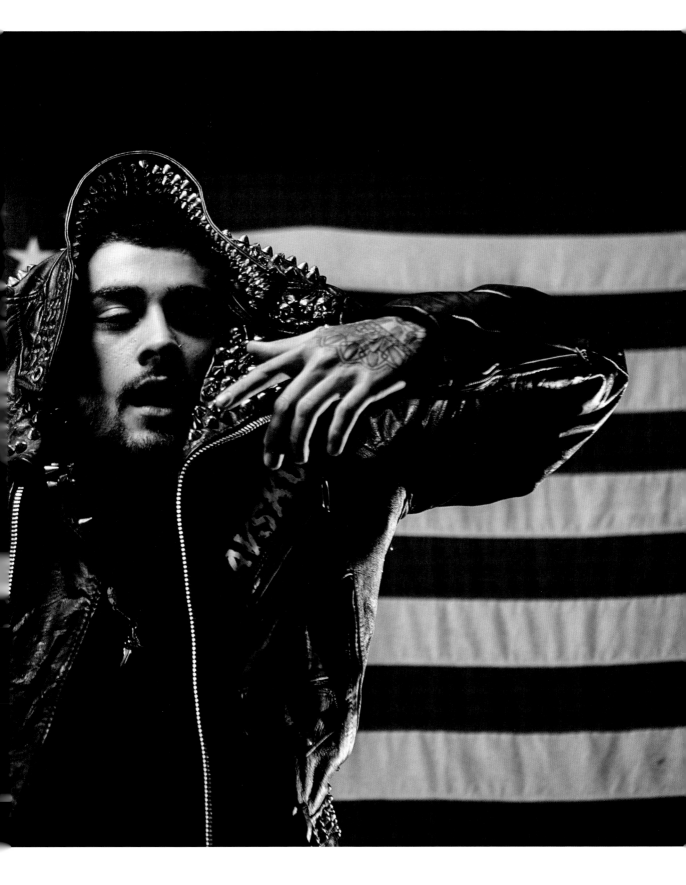

# STYLIST

After One Direction, I teamed up with a guy called Jason Rembert. He's a stylist who has worked with the likes of Rita Ora and Naomi Campbell, among others. I think he'd styled mainly women before me, so he was pleased to work with a bloke. It didn't take me long to learn to trust his judgement. Whenever it comes to dressing me, he looks out for stuff like vintage or one-of-a-kind bomber and leather jackets, which I love and wear all the time. He also tends to bring out a lot of vintage stuff whenever we're doing photo shoots or video filming, which is pretty sick.

At the same time, Jason knows that I'm quite into art, so he'll develop a look that he knows will fire my imagination. Everything we choose has to fit into the aesthetic of my music and my videos; it's all got to be there.

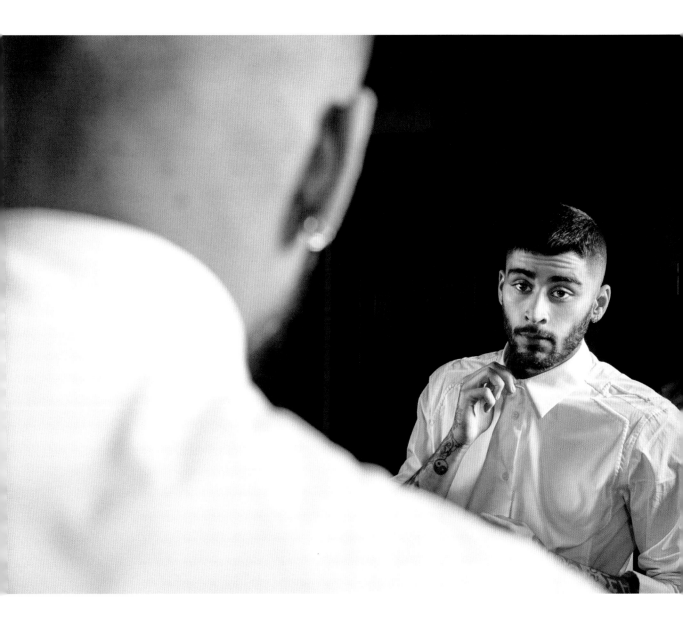

# NEW MANAGEMENT

A massive factor in my life post–One Direction has been the new people that I've surrounded myself with. Not just a new creative team, but a whole new style of management that has affected every area of my life. I was very sceptical of getting new management, but Shareena was the one who suggested I meet with Sarah Stennett, my current manager. I was open to the idea because Sarah managed a cool range of artists, who were a bit different and more eclectic than the straightforward pop world that I had experienced. But I still wasn't sure. I'd met with another potential manager before that and it hadn't gone well, but eventually I just figured, fuck it, I might as well meet Sarah, so I agreed. I met with her and also Nadia, who's of Asian descent like me. I tease Nadia that they had her meet me just so I'd be persuaded because there was another Asian person, but truth is, she knows her shit. They both do. Immediately when we started talking, I just knew instinctively that they had a very different approach. They were interested in what would work for me; they saw this as a long–term partnership where they could

help me develop creatively, on my own terms and in my own time, and I was really appreciative of that. It's great because I have the sort of relationship with them that I never had with management before. They'll come over to my house for dinner, we'll talk and we'll have a laugh. And they know when to give me a push and when to just let me do my own thing. They know when to tell me off, as well. I think part of what I saw in Sarah, and which I knew I needed, was somebody who could help me deal with me. When I get too up in my own head, it takes a very specific kind of person to be able to get me out of it, and Sarah has that ability.

I have a huge amount of respect for my management now, which is a sentence I didn't think I'd ever write. Like I said before, the fact that they are women, and that the whole management company is run predominantly by women, makes it feel a lot more supportive. I think there is a natural maternal instinct that comes out, which creates a much more nurturing environment. I've been accused of misogyny in the past,

for relationship stuff that's been twisted in the press and for bullshit that gets said, and that gets to me because I've always had a huge amount of respect for women, and I think that all the women who I've surrounded myself with in both a professional and personal capacity would agree with that. I was always brought up to respect women, both my parents instilled that in me, and in my experience women have been the most intelligent, peaceful and positive influences in my life. I don't want to generalize too much, but definitely in my experience, I've found the whole macho world of male aggression and insecurity to be a lot more difficult to exist in. That was my first experience of the music industry. Be a man, be brash, don't speak your true feelings, keep up a wall. Women seem to be able to move their barriers a lot more easily and will do so more selflessly, without always having an ulterior motive. That's something that draws me much more towards the company of women than other men.

The women in my life seem to have their emotional lives sorted in a way the men just don't. I always say, if you want a genuinely peaceful and intelligent solution to a problem, get a woman to solve it. That's why I wish there were more women in positions of power across the world. I think a lot of the world's problems could be solved if we allowed more contribution from women. I think I'm very blessed to have been raised by so many intelligent and impressive women, and now continuing that on a professional level, having people like Sarah and Nadia to guide me through this new phase of my career, is extremely significant.

'I WAS ALWAYS BROUGHT UP TO RESPECT WOMEN, BOTH MY PARENTS INSTILLED THAT IN ME, AND IN MY EXPERIENCE WOMEN HAVE BEEN THE MOST INTELLIGENT, PEACEFUL AND POSITIVE INFLUENCES IN MY LIFE.'

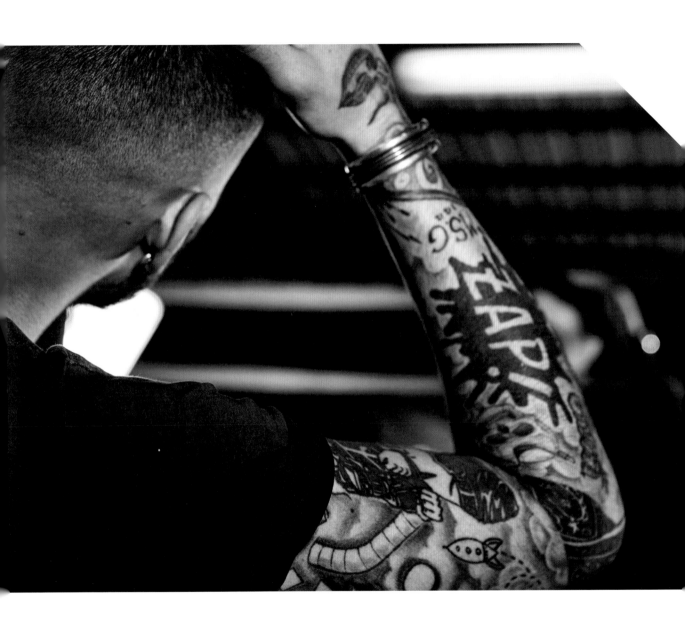

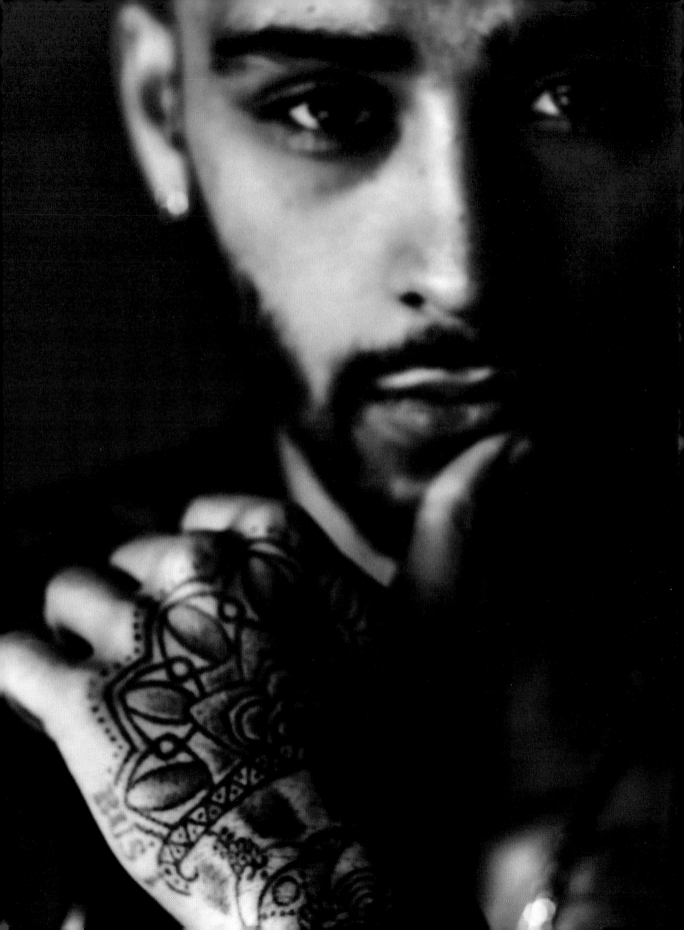

# 04.

# THE PLACE TO LOSE YOUR FEARS

'When I first got writing, I knew exactly what kind of music I didn't want to make. I was tired of straightforward pop.'

Malay was the first producer I knew I wanted to work with when I started on my album. I've been a massive fan of Frank Ocean since his album *Nostalgia, Ultra*. I remember listening to 'Super Rich Kids' while I was on our second tour and feeling like it just perfectly encapsulated my life. He got something about how a situation that looks perfect on the outside can be complicated and hard to deal with on the inside . . . and that was exactly what was happening in my life at that moment.

I asked my managers to go see Malay and play him some of the tunes I'd worked on up to that point with Alex from XYZ – the songs that would end up becoming 'Truth' and 'Fool For You'. They said Malay was super-quiet in the meeting. He just sat and absorbed everything with a complete poker face. Then at the end of the meeting, he swivelled his chair around and said, 'Yeah, I'm down.'

When I first came to LA, I was still working with the Hannides, but it was a natural segue into working with Malay, together with them. Mike, Ant and I had a song that we'd been working on that the beat wasn't quite right for, so we took it into Malay and he turned it into 'Borderz'.

I remember the first time we went into the studio with him, I thought he was a bit of a weirdo. Not in a bad way, I have my fair share of weirdness at times. Malay was just such a strange, unique human being. First off, he started every session by describing some crazy fancy bottle of red wine that he and his buddy Manny (who mixed half my album) were currently 'really into'. I had barely ever drunk red wine before, I'm more of a beer or whisky guy, but Malay somehow got me into drinking wine. I still don't do the swirl it around in the glass thing though – I'll leave that one to him.

Malay can also play pretty much any instrument in the book: guitar, bass, keys . . . I haven't seen him play the cello, but I think he probably could if you gave him an hour or two.

With the Hannides, there would always be some kind of idea that either I would bring to them or they would bring to me to start the writing process, but with Malay it was completely different. One thing that's great with him is his approach to the session. In our first series of sessions, I never came in with any particular idea. He would kind of ask me what was going on in my life, what I'd been up to, and then somehow start strumming chords on the guitar that seemed to always perfectly match the mood I'd been describing.

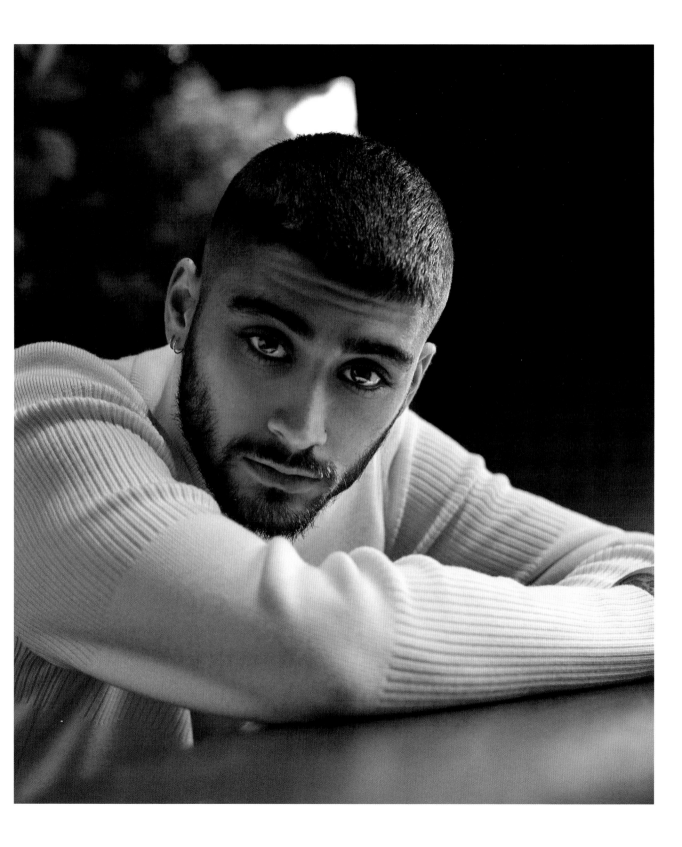

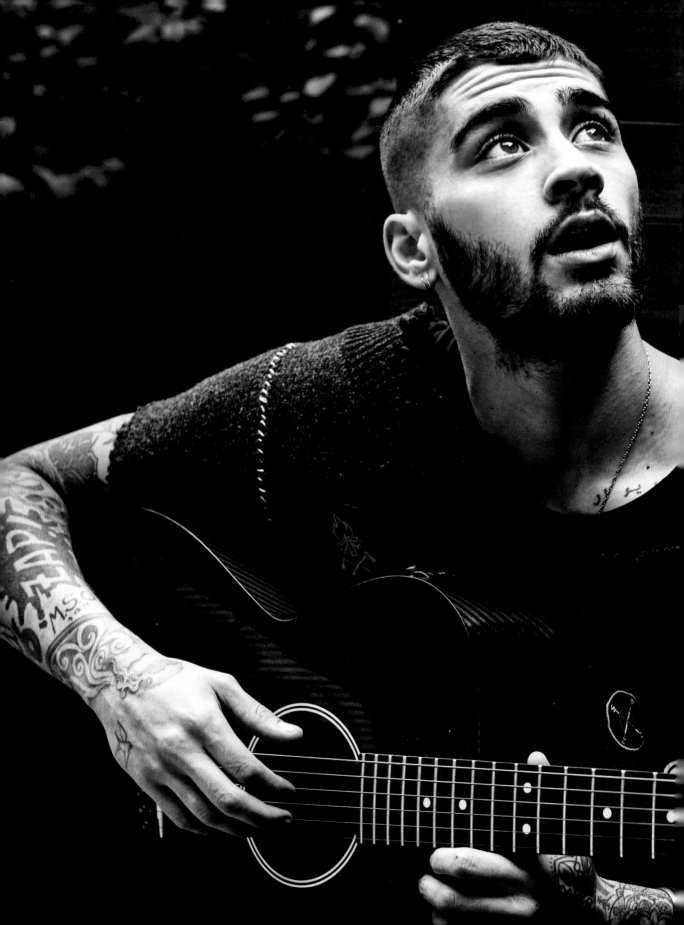

That was the basic process for some of the first songs we did together, 'iT's YoU', 'BRIGHT' and a few others that didn't make the album.

Another thing about Malay is that he knows music inside out; he can break it down – literally. I once watched him crack a microphone apart with a screwdriver before detailing exactly how everything inside it worked. He's very technically minded, which I really appreciate. He told me that when he was a kid he would open things up – CD players, any sort of gadget, really – just to check out what was going on inside. He wanted to learn what was happening in there. I was kind of similar, in a way; I had the same obsession with doing that as a kid, and I would rip apart old tape decks, anything I could find, except I wasn't really doing it for a reason. That was the difference between us. At least there was a purpose behind Malay's deconstruction: when he'd finished breaking a piece of electronic equipment apart, he would put it back together.

I like the fact that he pushes things that bit further. For example, there was a story going around about how he'd once slipped a condom over a microphone then dropped it into a bucket of water and waved it about. He recorded this series of mad, watery, whooshing noises and used them to construct a crazy beat. It's insane – here's a dude who can make a slimy condom sound wicked! I think Malay looks at music in a very different way to anybody else. He's into some *crazy shit*. It was cool to be around him and to bounce off that weird creativity.

At this time, when I first started working with Malay, I had just moved into my new house in Bel Air. The rooms were unfurnished back then, apart from some graffiti I'd sprayed all over the walls of course.

At night we would open up the windows and the sliding doors and lay down ideas. Sometimes, Malay would put a microphone in the garden and I would sing out in the open, underneath the stars. That was a really different recording experience, although it was nothing compared to our first proper writing 'adventure'.

'Bro, do you wanna go into the forest to write?' I suggested one day. 'We can camp in the woods . . .'

That might have sounded like a crazy idea, but I wanted a different vibe for the recording. Apart from singing in my garden, a lot of the time I was working in a studio environment, locked away from the outside world, never really quite sure what time of day it was. I wanted to get out there, feel alive, channel different vibes.

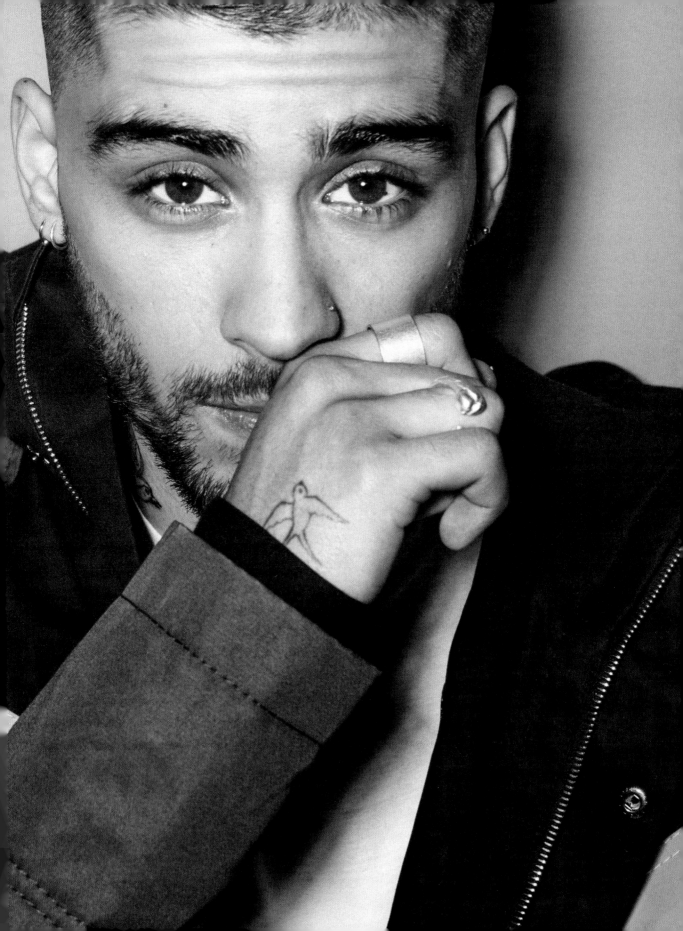

# OFF THE GRID

Malay was well on board with the idea. He had a portable recording rig that he took with him whenever he travelled, but he'd never recorded parts of an album in a forest before. I'd only got into camping quite recently. I'd never gone as a kid, even though it was something I'd always wanted to do when I lived in Bradford. Over the previous couple of years, I'd gone camping a few times with Perrie's dad, and I realized getting off the grid was something I really enjoyed. I liked being out in the woods. I liked sitting around a campfire, just drinking and hanging out. I often found that it inspired me to write lyrics – lots of them.

The Angeles National Forest is amazing. When we got into the wilderness, there was such a peaceful mood – all you could hear was the whisper of the trees. Malay brought a grill with him so we could cook, plus an air rifle and a bow and arrow, just in case we ran into any bears or mountain lions. What a move that was! I had never fired an arrow from a bow before, and one day I decided to give it a go. I really got into it, and it became the thing I did to keep myself entertained. I'd go out into the woods, using the trees as a target, and fire. Within two weeks, I swear, my arms had bulked up from pulling back the bowstring so much. My aim was pretty sharp, too, if I do say so myself.

We were out in the forest, in the middle of nowhere for two weeks. One night, we went for a walk and bumped into a deer – almost literally. We came round the corner and there it was, staring at us, the beams of our torches reflecting brightly off its eyes. Talk about deer in the headlights! Except it didn't seem scared of us at all. It didn't move. Didn't even flinch. It just stared back as if to say, 'And what?' Even though I knew it was harmless, I wasn't really a fan of being that near to it. Up close, it was massive. I kept trying to signal to Malay and eventually he was like, 'Er, yeah, OK. Let's go back to camp now.'

We set up a couple of tents – one for sleeping, another for recording – and made the place our temporary home. For the first week, we recorded whenever the mood took

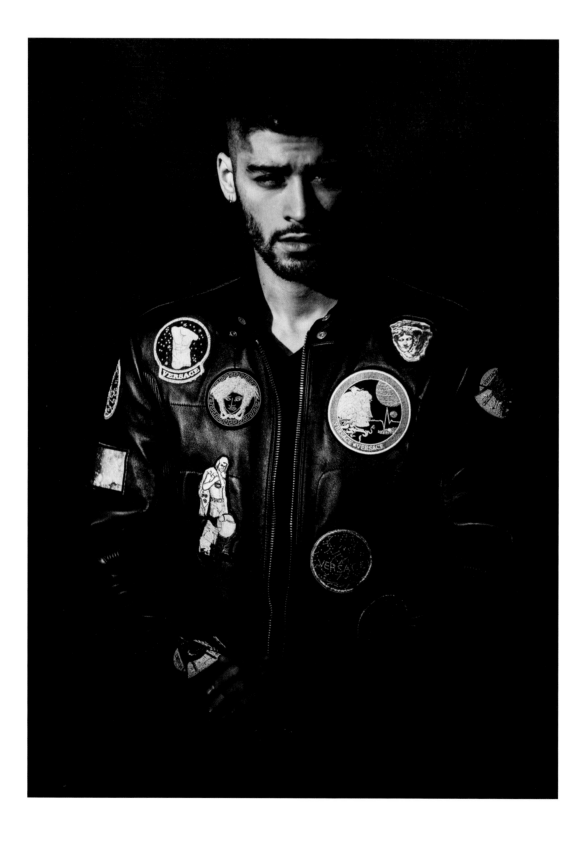

us, taking the odd break to fire arrows into the trees while we waited for the generator to power up. Some of the vocals we recorded out there were the best I'd ever done. I was learning a lot about being a solo artist. When I'm focused on doing something I really want to do, I can suddenly become so disciplined it's unreal. It just seems to come from nowhere, this drive to create. At that stage, I had several songs that needed finishing, and we got through all of those first. After that, I wrote some of the verses for 'Blue', and for a song called 'Dragonfly', which was a pretty sick tune, even though I didn't end up using it on the album.

The technical side of recording was quite tough. Even though there was nobody around us, there were still plenty of issues to deal with. The generator was noisy and, because it was so still and quiet in the forest, sound travelled from miles around. Sometimes there'd be people camping on another part of the hillside and the sound of them talking would travel all the way back to us. The slightest noise was amplified; the smallest outside noises could become a problem, so, for long periods of time, we couldn't really do a lot. In the studio back home, I had been pretty productive, sometimes writing up to seven tracks a day, but out in the wilderness our work slowed down big-time, from a technical point of view, but I didn't care.

I loved being away from the craziness of the city for a while. There was no reception out there, so we had no idea what was going on anywhere outside of our little camp. And nobody could get in touch with us. It felt so liberating. Being in nature, away from material possessions and the noise of modern life, fed my creativity. It's only when you're away from it all, off the grid, that you realize how crazy all of our neurotic dependency on 'owning things' is, all the stuff we think we need to make us happy. Truth is, out there, bow and arrow, tent, basic food . . . there's a peace in that. I also think it's really important to remind yourself of what really matters in life. It's so easy to get caught up in the glamour and the trappings of a certain kind of lifestyle, especially when you're young.

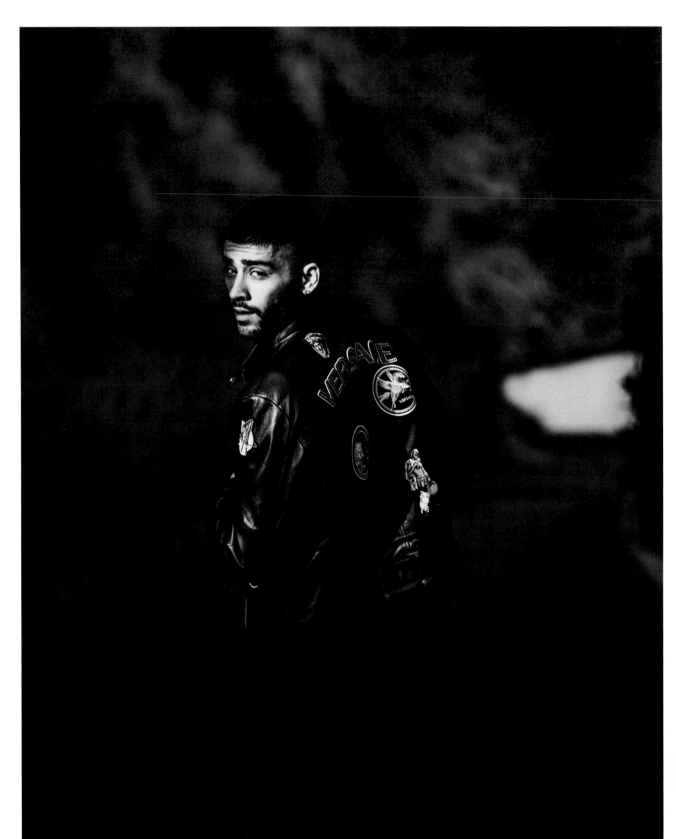

One particular experience which really made me realize how dangerous a certain lifestyle can be and how easy it is to lose perspective on things was when I had the opportunity to go to Ghana for Comic Relief. It was my nineteenth birthday. I had been in the band for over a year and had already started to place value on things that I had never even had before: expensive clothes and shoes, cars, watches, a big house. I was so caught up in it all and had so lost sight of myself.

I learned so much on that trip. I saw such incredible humility from people, the kind of humility and selflessness that we rarely see in our privileged Western lives. Kids who willingly put themselves in harm's way to protect their younger siblings, who risk their lives to gain an education. Elderly people who got down on their hands and knees to care for the sick. There's one kid I will never forget. He didn't speak any English so we had to communicate through a translator, but his eyes spoke volumes to me and he seemed to be saying, 'Help me'.

It was such an emotional trip, I was a wreck for most of it. Everybody says money doesn't buy you happiness, but we forget what that really means. I think being able to step back and see your privilege for what it is is such an important skill and something that we all struggle with at times. That's why getting away from everything, just allowing your-self to exist in nature and to reflect, is really important.

'IT'S ONLY WHEN YOU'RE AWAY FROM IT ALL, OFF THE GRID, THAT YOU REALIZE HOW CRAZY ALL OF OUR NEUROTIC DEPENDENCY ON "OWNING THINGS" IS.'

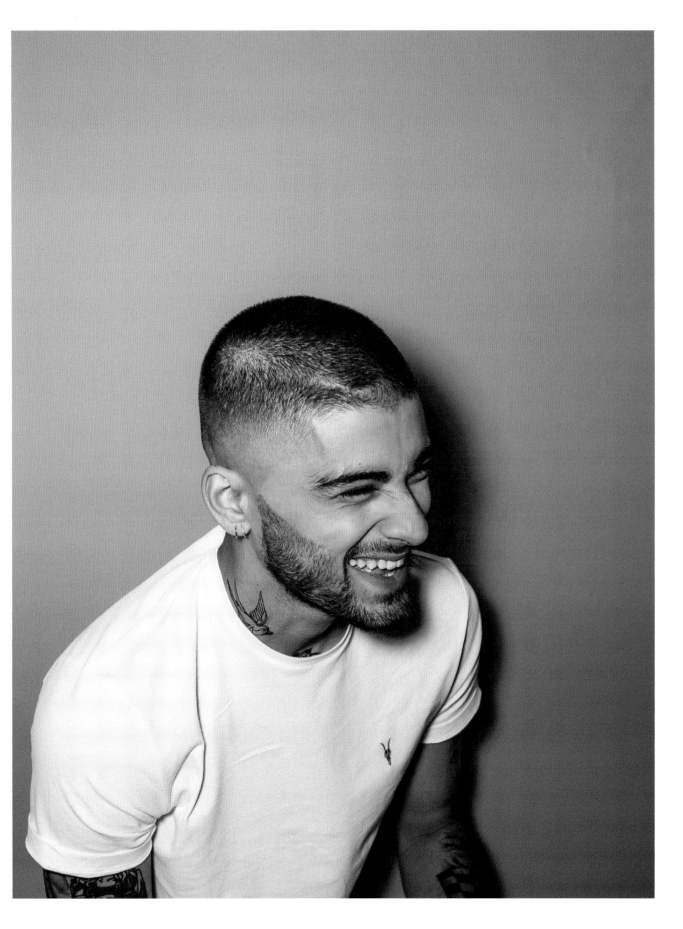

## ⊘ SONG NOTES
# 'INTERMISSION: FLOWER'

One day when I was working with Malay, we got to talking about my dad. I was telling Malay about my relationship with him and how important it was for me to do well for him, to earn his approval. My dad's a hard worker and he has strong values. He was a personal trainer and is solidly built, and he used to go on at me all the time about being a good student and getting the right education. He wanted the best for me, and I wanted to please him in return. The fact that he hadn't been so sure about me going solo at first had fired me up. I wanted to show him, as much as everyone else, that I could do it, and once the tracks started coming together with Malay and a number of other producers I'd been working with, I began to feel that I was really able to express myself vocally and I hoped my parents were going to see it from my side.

'Man, I know if Dad was to hear me sing like this,' I said to Malay one time, 'it would mean everything.'

Back in the city, we were hanging out one day, shopping for musical instruments, and I told Malay that I wanted to play a lot more guitar. That's when he told me about the Martin Backpacker.

'It's a little travel-sized thing,' he said. 'You can take it anywhere, it's the size of a backpack. It's like a mini-guitar.'

When we found a shop that had one, I bought it, and I loved it from the minute I started playing it.

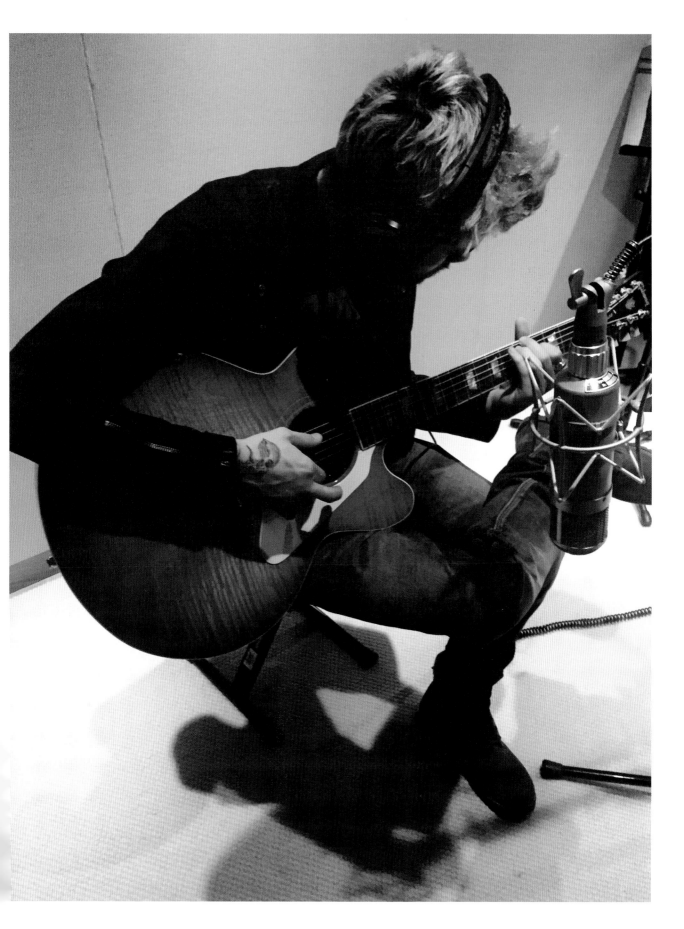

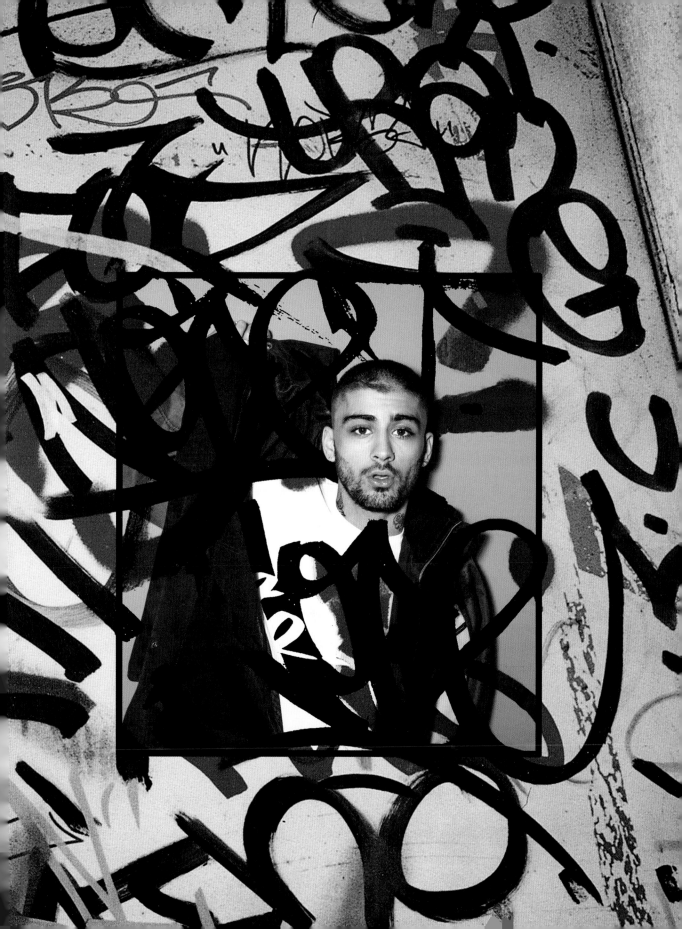

# I NEED THIS LIKE I NEED YOU

Not long afterwards, Malay and me were spending an afternoon sitting around the pool at the Beverly Hills Hotel, writing down lyrics and messing about with melodies. Malay had his portable recording rig with him and the pair of us were talking about the Pakistani musician Nusrat Fateh Ali Khan. I was really into him, because my dad had played his music a lot at home; I loved that the dude sang in Urdu, for one thing. A lot of people who know his music reckon he was one of the greatest artists of all time. He also turned a lot of people on to qawwali music.

As we were chatting, Malay picked up the Martin Backpacker and began playing a little riff, based on an idea I'd shown him earlier that day – a melody I'd been playing with. He added a few twists and, immediately, it sounded amazing. I was like, 'Man, this is so cool. We should record some of this. And I think I want to sing this one in Urdu, like Nusrat Fateh Ali Khan.'

Malay set up the mic by the pool. There was a little waterfall nearby that was rippling away, and it really added to the atmosphere.

I knew that Nusrat Fateh Ali Khan's music came from a spiritual place, and it was also almost like jazz: his band would find a hook, and they would sing and play it, but what happened next was pretty much improvisation. 'Intermission: Flowers' soon took on a similar vibe. I was just riffing lyrics in Urdu over Malay's looped guitar, and we got it down.

Nusrat Fateh Ali Khan passed away in 1997, but in May 2016 I heard talk that his nephew wanted to perform with me, to do a gig somewhere in India. He had taken on being the main guy in the band after his uncle's death and, once he'd heard the story of 'Flower', he reached out. Doing something with him – anything – would be an honour. Fingers crossed we can make it work.

By the way, here's the translation of the lyrics: *'Until the flower of this love has blossomed / This heart won't be at peace Give me your heart . . .'*

I DONE THIS BEFORE
BUT NOT LIKE THIS
ON SOME HIGH
SHIT
THINK I LIKE

LIKE A PHOENIX
~~XX~~ ~~XXX~~ WE RISE
~~STEEP~~ FLYING OUT
FROM THE ASH
~~XXXXXX~~ ~~XXXXXX~~
~~XXXX~~ I DID GO AWAY
BUT NOW IM BACK

I'VE
DONE
THIS
BEFORE...
NOT LIKE THIS

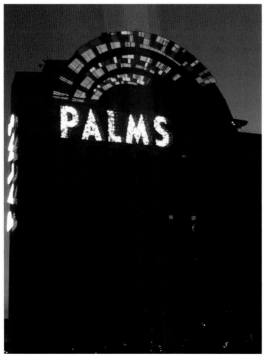

# LAS VEGAS

One particular experience with Malay that I'll never forget was when we decided one night to go to Vegas together. He told me that there was a studio in the Palms Hotel, so I called up Shareena, and within a few hours, we were headed to Vegas.

No offense to the Palms, but it's definitely not the poshest hotel in Vegas. A lot of the new ones are flashy and shiny, and that's where we stayed in the band when One Direction went to Vegas. The Palms has an old-school charm to it, even if it borders on being a bit grubby. There was a massive stench of trash in the loading-dock entrance they brought us in, even though there wasn't a dumpster anywhere in sight. The lobby smelled like there was cigarette smoke in the air that had been there since the sixties.

The suite they put me in was absolutely amazing. It had the never-ending pool, a massive lounge, hot tub, the whole nine. The entire crew (myself, Ned, my tailor Griff, Jason and Malay) went out that night to Drai's, where Big Sean was performing. We had a few drinks and headed back to the hotel. We ended up throwing a massive party in the suite, there were probably about 150 people there – somehow. I think Skrillex showed up, if my memory serves me correctly. And at one point in the night, I remember turning to Malay and just saying, 'I've been here before, but not like this.'

When Malay heard me say that lyric, his eyes lit up and he said let's go to the studio. We left the party when it was in full swing and went downstairs. Malay instantly knew the chords – he was already humming them in the elevator on the way down. We came up with the first verse and chorus in about an hour, and then came back up to find that the party had died down a bit (it was nearly sunrise at this point). The next day we woke up to an absolute shitstorm of a hotel room. There were bottles everywhere, and one of the couches was still completely soaked in champagne!

The place to lose your fears

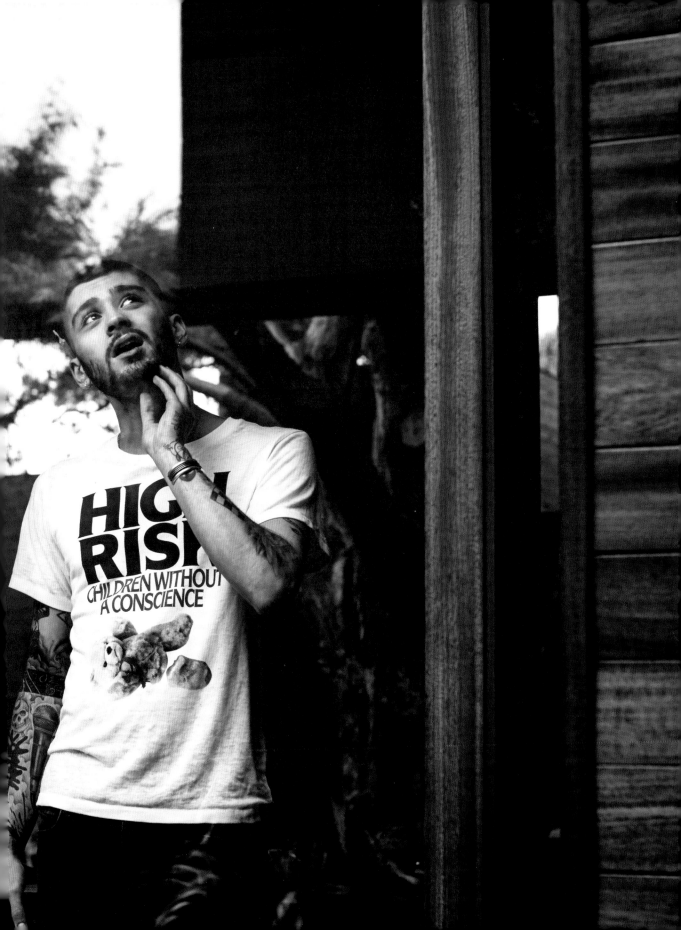

## (◉) SONG NOTES
# 'BEFOUR'

The result of that burst of inspiration at the Palms and that late night session was 'BeFoUr', a track that made it on to *Mind of Mine*. The lyrics are '*I don't drink to get drunk / I feel all the right funk / If there's something I want / I'll take all the right wrongs . . .*'

I'm the kind of artist who gets an idea and wants to run with it straight away, rather than taking weeks and weeks to get it down. That's definitely what worked for me on this song. I was really pleased with the way the lyrics turned out, and Malay was the one who gave it a twist. When he worked with Frank Ocean on his debut, *Channel Orange*, he'd made an album with a left-field sound but he was still able to stretch it into the mainstream. That was exactly what I was hoping we'd do with my tracks.

(◯◯)

Dragon FLY →    Life Span ☼

(Vegas)

I've been here before
But    Not    Like    This

Now I'm on the roof
Set it on fire
Just to give me proof
I'm living on a ~~wire~~ wire

~~So say what u gotta say now~~
~~So say what u wanna~~

So say what u wanna say
what u want rite

what u gotta say now

N - O - W

I dont drink to get drunk
I feel all this rite funk

## ◑ SONG NOTES
# 'DRAGONFLY'

This was a song that didn't make it on to *Mind of Mine*, but it was close. The track was loud, with a rocky sort of vibe: pounding drums, hard guitars — it was heavy-metal shit. The only reason it didn't make the album was that it didn't fit with the rest of the tracks on there, but I might release it at some point in the future. I might even give it to someone else for them to record — who knows?

The idea for the song came when I was staying in the Beverly Hills Hotel. I had been jamming on the guitar, Malay was writing a riff on his, and I noticed some dragonflies. I sat there, just watching them buzzing about the place — they were there for ages — and it got me thinking.

'Do you know that dragonflies have a really short lifespan, like, a year?' I said.

Malay just looked at me, confused.

'Yeah, they only live for a little while,' I said.

And I got really hooked on that idea, the concept of having to get everything done right now, in the moment, because there's no time to waste.

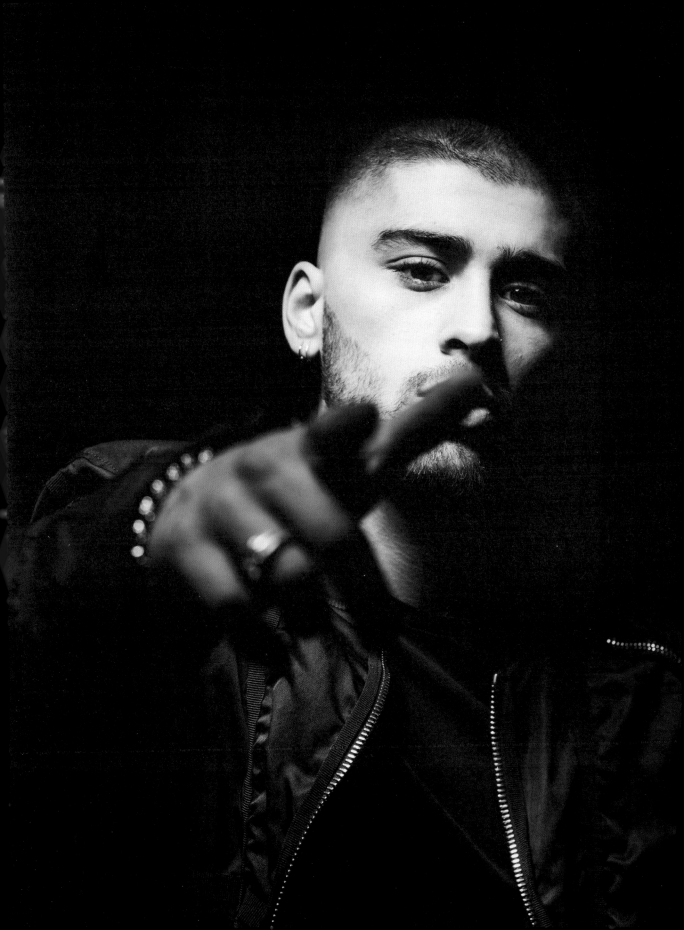

# ⌀ SONG NOTES
# 'BLUE'

Just after I'd left One Direction, when I was staying in the Beverley Hills Hotel, I wasn't sleeping much — jetlag, the stress of it all; I had a whole lot of emotions going on — so I would record at all sorts of hours. Malay was staying there, too, so whenever the mood took hold I would knock on his door.

The session for 'Blue' took place at around that time and, when it came to writing and recording, the craziest thing happened. I think I got it down in one, maybe two, takes. It just poured out of me in a rush. I was in the zone. Everything felt weird — *nice* weird; I didn't really have any idea what was happening. I was standing there, just singing, and all these proper odd words came out, and the melodies had a real swing to them, which wasn't a style I'd really done much before. I think I was picking up on an old-school vibe from the hotel.

It's mad how much of an effect your surroundings can have. The room I was staying in had a framed shot of Frank Sinatra on the wall; apparently, he stayed at the Beverly Hills Hotel quite a lot back in the day. All the Hollywood superstars used to hang out there: Charlie Chaplin, Marilyn Monroe, John Wayne . . . Some rock'n'roll guests checked in, too — John Lennon and Yoko Ono stayed for a while. When Frank was there, he and the legendary Rat Pack — Dean Martin, Sammy Davis Jr. and the rest — would get into some heavy drinking sessions in the Polo Lounge. I'm sure that whole atmosphere was a huge influence in creating and shaping 'Blue'.

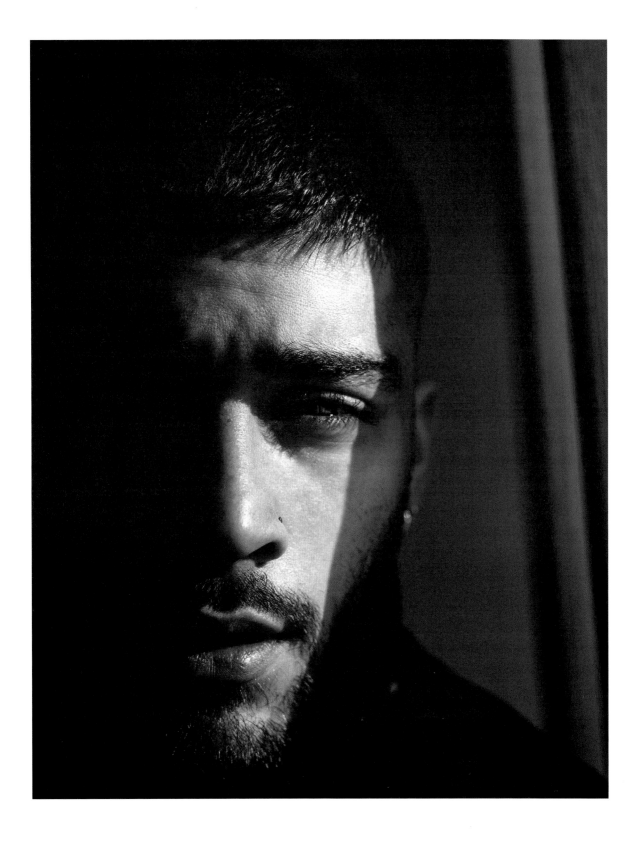

## ◻ POLAROID
# BOB MARLEY COLLAGE

When I finally moved into my house in LA, it was kind of like a blank canvas. I'd pushed really hard to get that house. It was just so chill. It's not like some big mansion in Bel Air. It's just one level, two bedrooms – pretty basic. All the rooms are white and the floors are stripped bare, no carpets or anything, just concrete. It's cool. There's a vibe about it that I find really relaxing, and that's exactly what I was looking for in LA. I was so pumped when I finally signed the papers that I wanted to move in straight away, even though it was totally empty and I didn't have a single piece of furniture, just my Buddha statue. So I brought the equipment from when I'd been camping with Malay inside and set up camp indoors. I slept in a sleeping bag with a pillow on the floor. Some of my team came round and we had a bit of a house-warming, and we sat around in the living room on camping chairs. It's fucking funny when I think about it now. At the time, I was just glad to find a space that I felt was my own. One of the first things I did at that house was spray paint a mural in the style of the logo from *The Fresh Prince of Bel Air*. I wanted to make my mark.

I make a lot of collages, too, out of stuff that's important or inspirational to me, or sometimes just stuff that looks sick, and I put them on the walls. I cut shit out of various magazines and use posters or record sleeves: in one of my collages there's the cover of Nirvana's album *Nevermind* and the Rolling Stones logo. I put up some Day of the Dead imagery, some X-Men pictures, and one of Bob Marley. What a hero.

It was my dad who got me into him. As I got a bit older, into my teens, I started taking an interest in Marley's back catalogue. I loved his music, but there was so much more to respect about the guy. I'd watch his interviews on YouTube, and he's so interesting; he was a political guy, and he took some brave stands during his career. Shortly before he was due to perform at a gig called Smile Jamaica – a gig that was all about bringing a peaceful end to the conflict going on in Jamaica at the time – he was shot. Gunmen attacked his house and sprayed bullets everywhere. Somehow, he survived. Even more impressive, he still played the show. Stories like that make me admire and respect him as a person, not just as a phenomenal musician. Finding all this stuff out about him made me listen to his lyrics in a different way. Next to him I've got a picture of King Haile Selassie, the man Rastafarians call Jah – Soul-Jah! I put those two next to each other because Rastafarianism was Bob Marley's religion.

WE COME
IN
PEACE'S

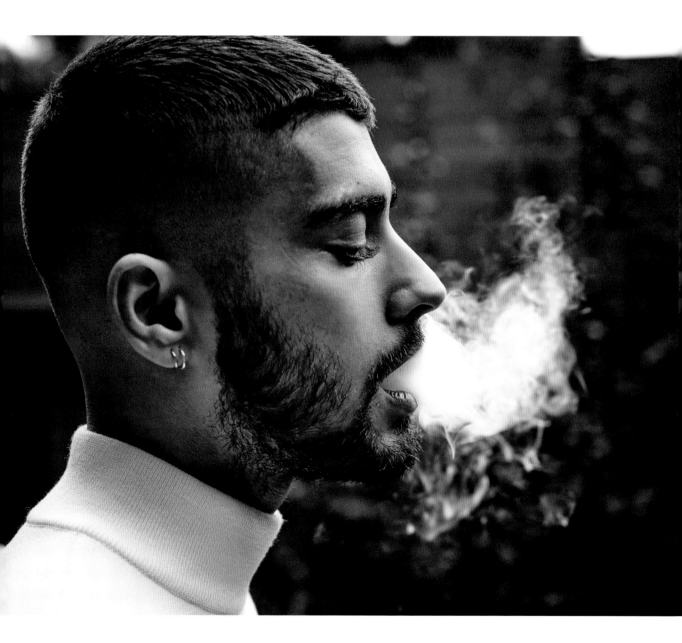

# SONG NOTES
# 'IT'S YOU'

At one point when we were both in LA, I texted Malay some lyrics. I'd just written the opening lines to 'It's You' and I wanted to share them with him as soon as I could: *'She got, she got, she got / Her own reasons for talking to me / She don't, she don't, she don't / Give a fuck about what I need . . .'*

I had a loose idea for the chorus in mind, too, and I knew Malay would be excited by the concept, so we quickly put together the song in Larrabee Studios before going to my house to get the vocals together. The only downside of the house was the acoustics — they were shit, not that it bothered Malay. Like I said, he's a fucking genius when it comes to production. He could build the perfect sound in a restaurant kitchen, that's how skilled he is. And it didn't matter what sort of equipment we were using either: I might have a $300 microphone or one costing $20,000. Both would sound incredible once Malay had got to work.

On 'It's You' we needed some extra percussion to finish it off, a shaker maybe, but he was like 'I don't want to use a regular shaker. Zayn, have you got a $20 bill?'

I handed one over and, before I could even ask what he was doing, he was rubbing the two ends of the note together to make this soft, shaking sound. Then he distorted the recording to make it sound like a weird maraca.

The man's a genius. Though I don't remember getting my $20 back!

She got her own reasons
for talking to me
. She don't give a fuck about
what I need.

I cant tell you why
Because my brain can't equate it
Tell me ur lies
Because I just can't face it

It's you...........

Could all of this go away.........
For 1 Day

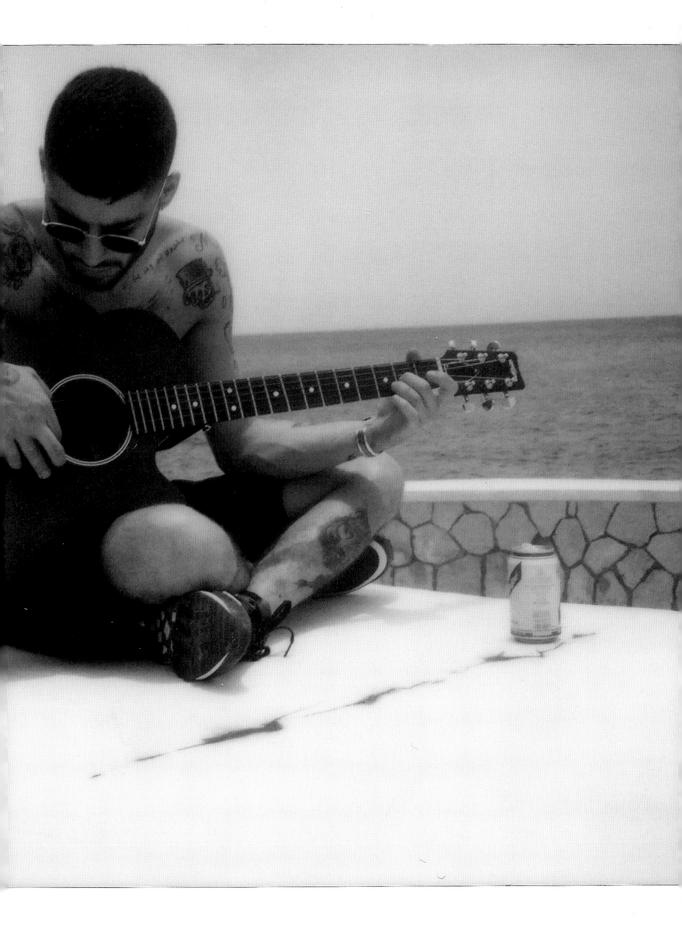

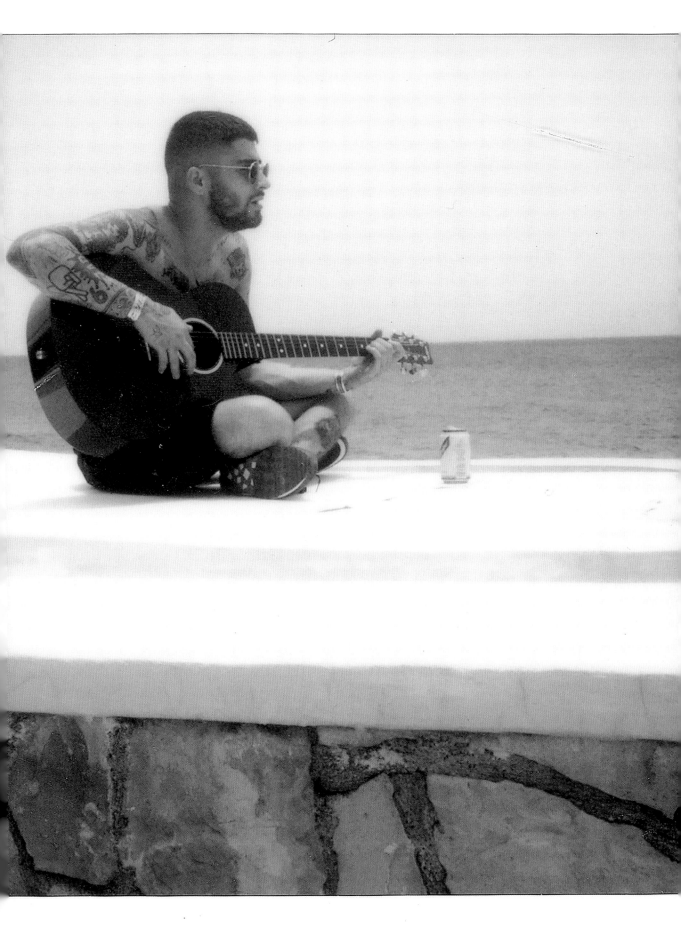

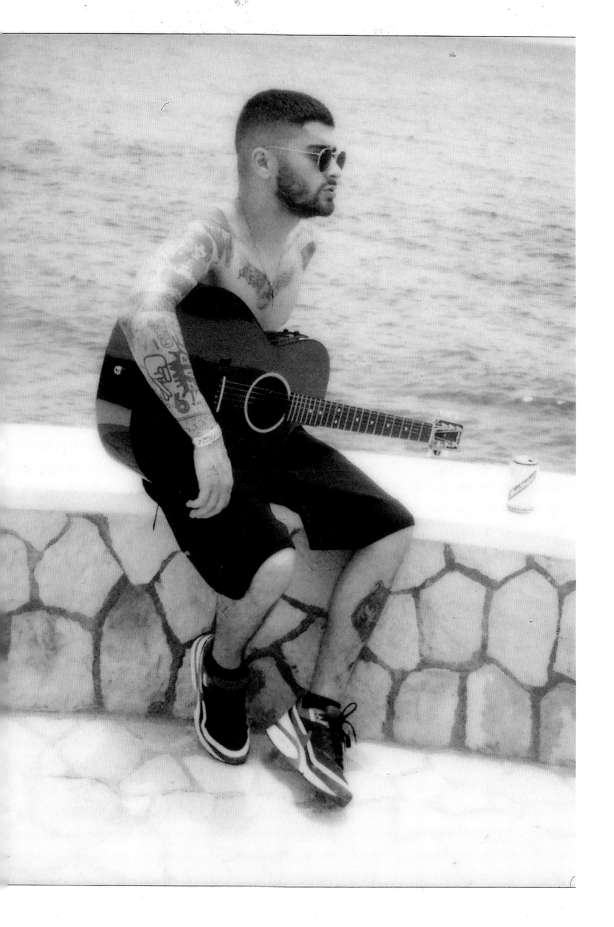

# 中品 STUDIO VIBE
# MALAY ON ZAYN

I'd heard of One Direction, but I hadn't necessarily followed them at all, so I made sure to listen to a few of their songs before meeting with Zayn. But once I'd heard the stuff that Zayn had made with XYZ and MYKL, I loved it. I was like, 'Oh, wow, this is crazy.' I was definitely surprised. His vocal tone is so unique, which is something I always look for first when I decide whether to work with a singer-songwriter.

Zayn is a true artist. He's got vision, and he's pretty clear about what he wants to do. It also helps that he's really creative – he's always drawing, painting or writing stuff; he's reading all the time, and it comes out in his lyrics. He's just forever exercising that part of his brain, and I'm excited to see where he ends up. This is just the beginning for him. Now that he's getting started, I can only imagine where he's going to be in a few years.

We had a good songwriting process in place. Usually, a song would start with a discussion. That would lead us to a concept and, from there, he would write lyrics that stemmed from personal experiences – either stuff that he might have been going through at the time, or things he had lived through previously. He was also inspired by the fact that I had put together a portable recording rig. Once Zayn found that out, he got really excited. He really didn't want his studio work to become formulaic. Zayn had experienced that before, during his time with One Direction, where he had to be in studios at certain times; people told him how to sing and what to sing. We would take the opportunity to record outside the studio as much as we could.

I think we hit it off because I understood him and his vision, which is something I strive to do with any artist I work with. I think by the time he came to decide upon what was going to be on the album, he had over forty songs, which must have made choosing the final cut a bit problematic. But he won't stop writing. I'm excited to see where he goes, and I can easily see him delving into different genres of music to make some super-creative albums.

He has the room and the freedom to do that now. The more time goes by, the less he'll be regarded as 'that guy who left One Direction'. People will see him as a solo artist in his own right, not just a singer who left a band. And that will only help him to push his creativity to the utmost.

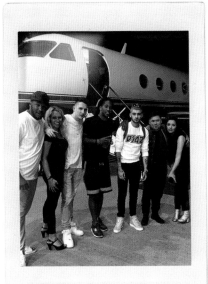

STUDIO!

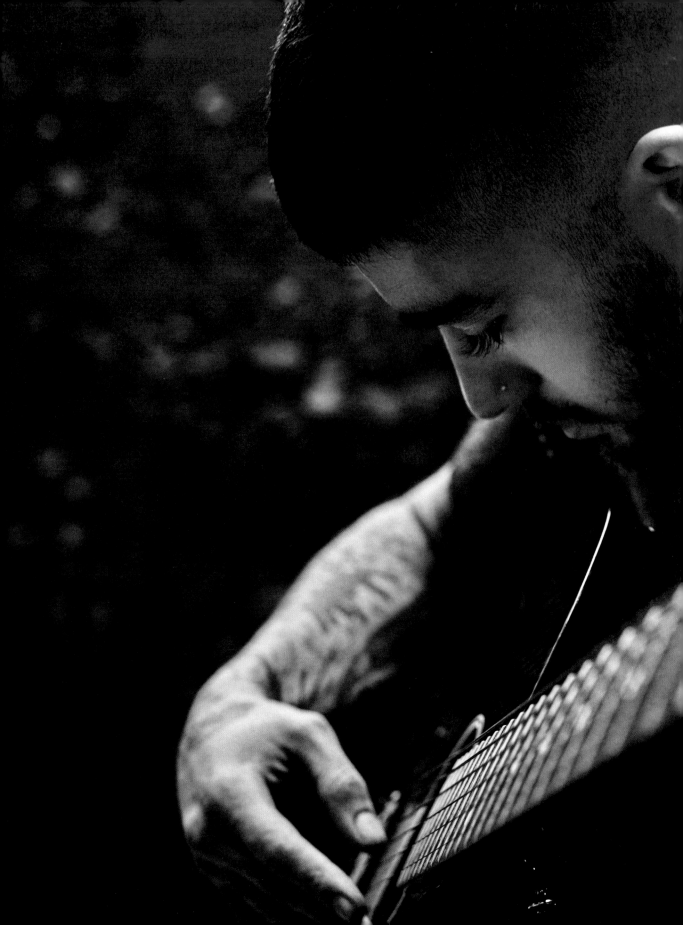

# 05.

# SEEING THE PAIN, SEEING THE PLEASURE

'I owe my fans a lot. I always have done, which was why it was so hard to walk away from One Direction.'

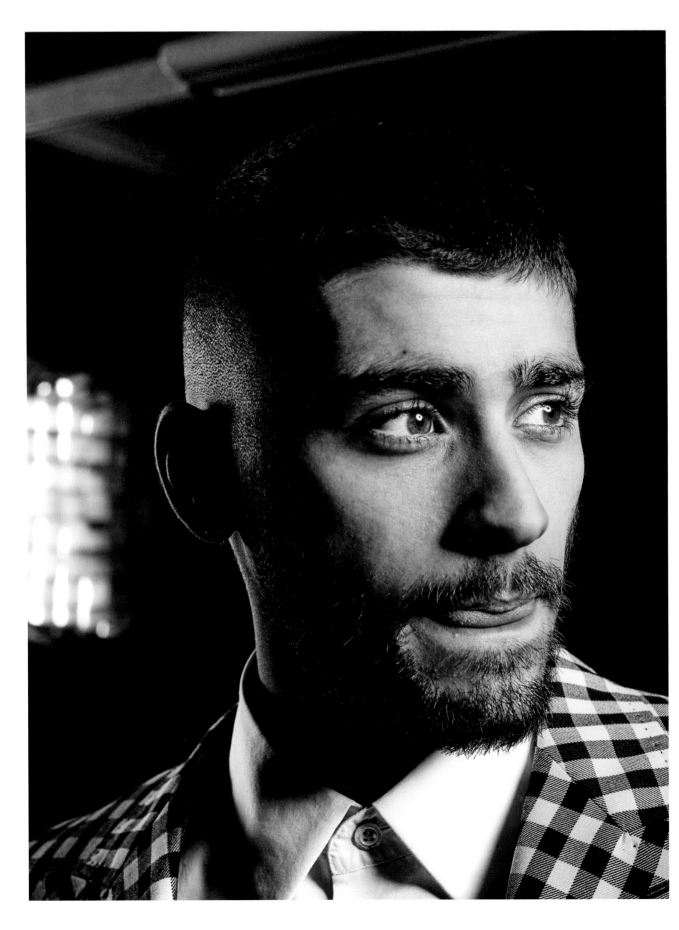

'ALL I'VE EVER FELT FOR THE PEOPLE
WHO HAVE SUPPORTED ME THROUGHOUT
MY CAREER IS APPRECIATION.'

When I look back at images of myself from around November 2014, before the final tour, I can see how ill I was. Something I've never talked about in public before, but which I have come to terms with since leaving the band, is that I was suffering from an eating disorder. It wasn't as though I had any concerns about my weight or anything like that, I'd just go for days — sometimes two or three days straight — without eating anything at all. It got quite serious, although at the time I didn't recognize it for what it was. I think it was about control. I didn't feel like I had control over anything else in my life, but food was something I could control, so I did.

After I had decided to leave the band, a statement was written and put out so quickly it made me feel trapped. The fans had been given the impression that I was leaving music for good.

But once I'd had a chance to explain to everyone why I had left and that I wanted to make my own music — music that was very different to the stuff we had been recording previously — they seemed to get it. Not long afterwards, the fans seemed to be really keen to find out about what I was doing with XYZ, MYKL and Malay, which was proper encouraging. They wanted to hear the new stuff and get a glimpse of the angle I was taking. Every day there were new tweets, like, 'For fuck's sake, man. Where's your new shit? Release it. You've been working on it for ages!'

'I WANTED TO MAKE MY OWN MUSIC – MUSIC THAT WAS VERY DIFFERENT TO THE STUFF WE HAD BEEN RECORDING PREVIOUSLY.'

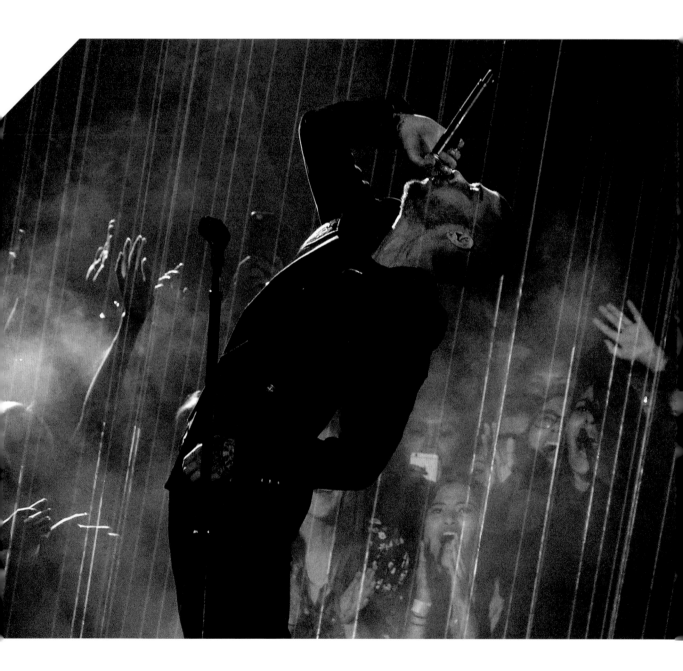

# FANDOM

There's this whole online culture of fandom which seems pretty impenetrable from the outside. There's fan fiction and, when I was still in One Direction, fans would write stories based on me and the other lads and publish them online. I'm not gonna lie, it's pretty unnerving reading things about yourself as a character from somebody else's imagination – but it's cool to see that so many fans engaged with the band on their own terms like that. It's crazy to think that we inspired so many different stories and the opportunity for so much creativity from so many people all over the world. My favourite stuff, personally, is fan art. I love seeing how many different ways people interpret my lyrics and my style, and it's so cool that they share that with me. It's also weirdly touching to see how many talented people out there choose to apply that talent to something connected with me and my music. It's really humbling.

I don't think I'll ever get over the idea of having 'fans'. When I was growing up I witnessed all my aunts, sisters and, of course, my mum going nuts over whatever singer or film star was big at one time or another. I still don't really get how I seem to have become part of something that other people's sisters were going crazy over. Now that my solo stuff is getting attention, it's kind of different to how it was when I was in the band. Obviously it's cool to have people investing their time and energy in me and my music, and I appreciate it means that I've got a lot more responsibility towards those fans.

After the split, I hoped that the fans would still relate to me. I'm just like them. I've fucked up publicly a few times, but the mistakes I've made are things that a lot of fans will have experienced, too. I'm hardly perfect, and they can relate to that. A lot of them will have been in the same situations themselves. I also like to think I've done some good stuff. A big deal to me was joining the British Asian Trust as an official ambassador. It's a charity that does a lot of great work, and it's really close to my heart. I've been able to donate a bunch of One Direction memorabilia to make money for different charities. And I've bought a box at Bradford City so kids who might not have the chance otherwise can go there and watch the matches, have a day out and have some fun.

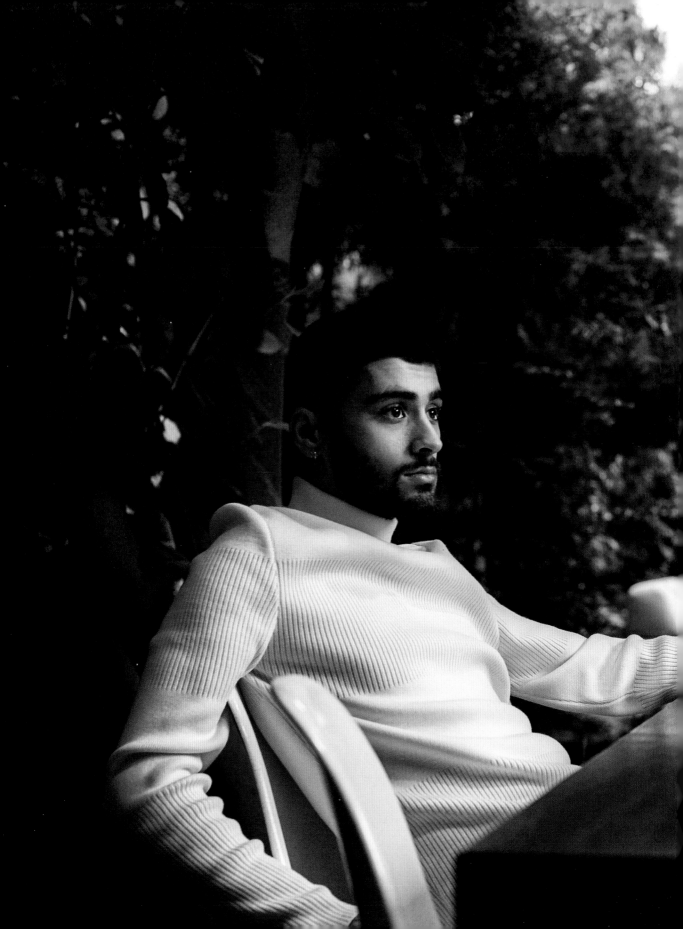

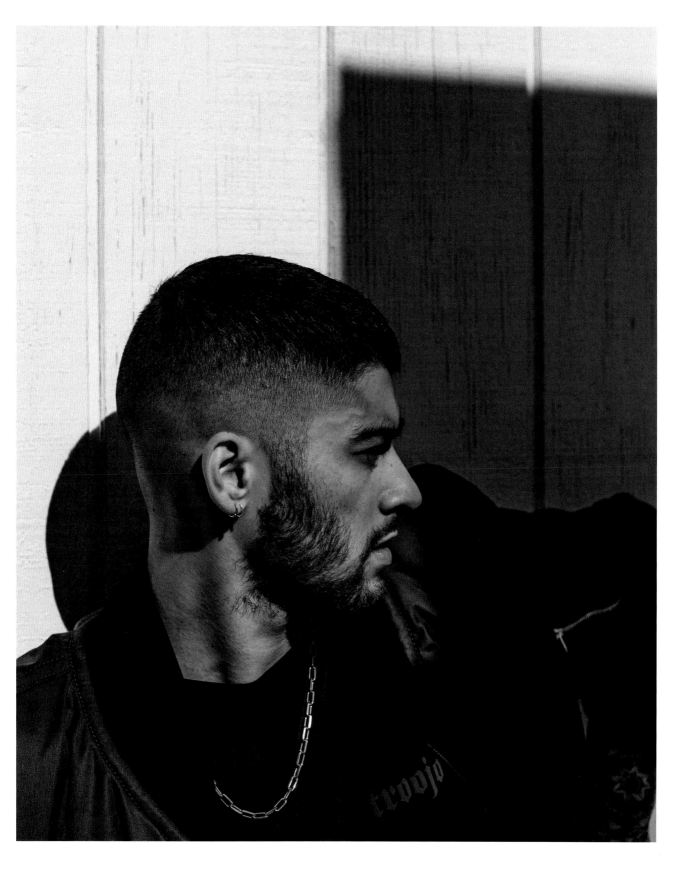

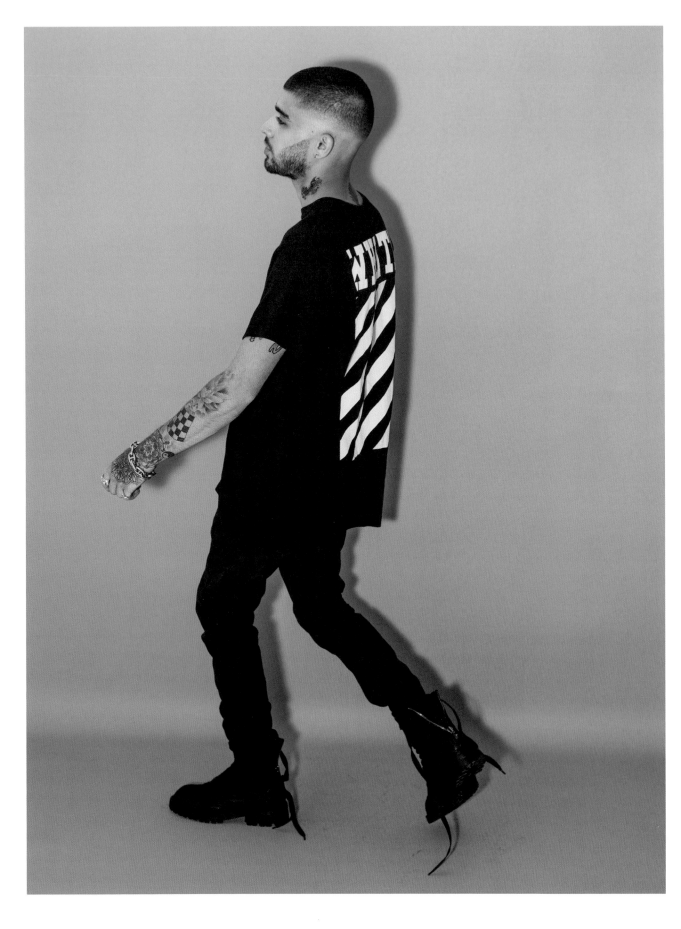

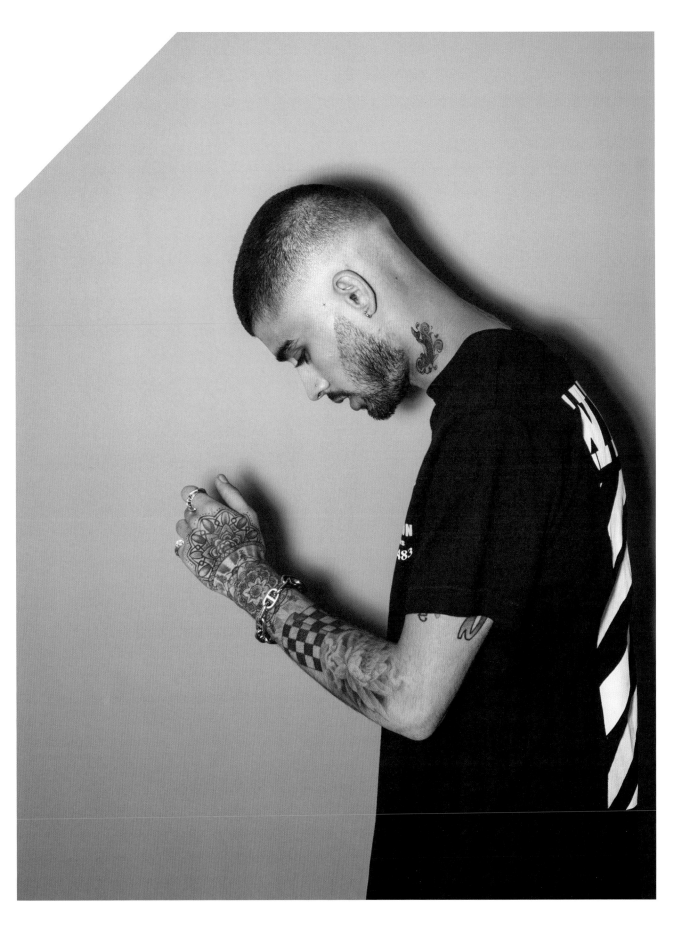

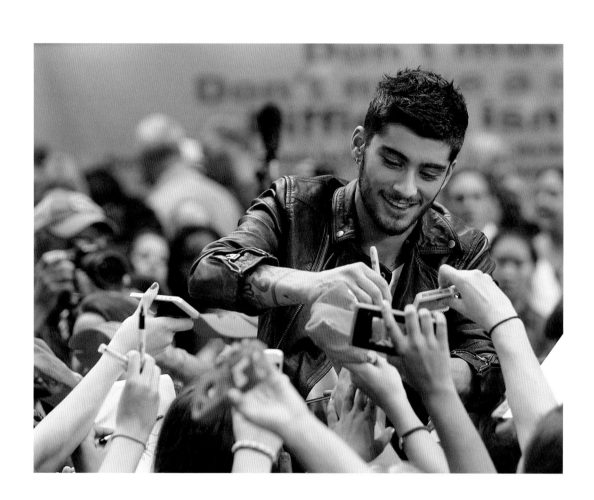

# SOCIAL MEDIA

Sometimes, it's hard not to upset people, especially on social media, so I just try to keep myself to myself. When people ask me what I think about the big issues – and faith is one of them – I try to keep my mouth shut. I don't want to be influencing people's opinions or feelings on important issues; it's up to them to decide what they think and feel about things.

I probably spend a good few hours every day on social media. Often I don't post, but I'm looking at my followers and reading their comments. I'm not sure if that's always a good thing. Sometimes it means that when somebody says, 'Oh, congratulations, that song's doing really well,' or something like that, I just think, 'Is it, though, because I've just spent ages reading through all the comments?' Some people can be pretty fucking brutal. That's part of why I sometimes don't post or comment as much as I could, or as much as my followers want me to. Don't get me wrong, I do try to reply to fans when I see something that especially makes me laugh or whatever, and I really appreciate how lots of people send me nice stuff every day. But getting your voice across online in an authentic way is difficult. There are always so many different ways people can interpret, or misinterpret, what you say, and it can be really frustrating. That's why I generally stay away from controversial topics. If something gets twisted or taken out of context, you can find that your own words have been turned into something you didn't mean, and a bunch of people are sending you hate mail. I think you've got to take time to properly think about the words you want to use. That's part of why I wanted to write this book. At least this way I have the time to think about what I want to say.

# RELIGION

People seem quite keen to make something of the fact that I'm Muslim. I was brought up with a good set of morals, and that's all down to my mum and dad, but I generally try not to make a big deal out of my religion, or start talking about my political opinions in public. It's the same with lots of my tattoos: they're written in Arabic, and they're personal. I keep them out of view; they're in places that not many people are going to see.

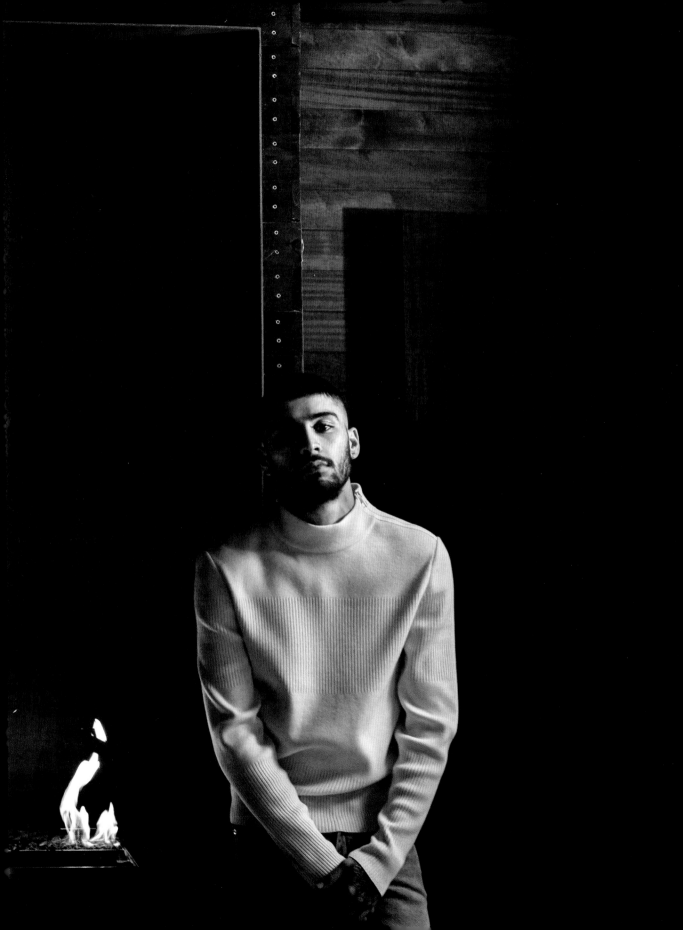

## ⊙ SONG NOTES
# 'LUCOZADE'

It was Bonfire Night and we were driving through London to XYZ's home studio in Kensal Rise. Everyone was cruising around, heading off to firework displays, and we saw these guys selling weird lights on a stick. They had a wheel at the end that lit up in all sorts of mad colours as it whizzed around, a bit like a Catherine wheel. We pulled over to grab some for the guys in the studio. They were also selling drinks, so I picked up a couple of bottles of pink Lucozade.

I like XYZ's studio. It's not fancy – it's a shed at the bottom of a garden in North London – but I was into the fact it was so basic. It was just a room with a bunch of synths lying around. Sometimes, a big studio can be too intense. A tiny one is just my scene.

It often takes me a while to get going when I'm recording a track. I'll warm up slowly and find my feet. I like to have a drink to unwind, but really I'm just getting into the mood, the light, the space. Then things start happening. I'm totally focused on writing when I get into a studio these days. I don't have to stress about leaving early for a photo shoot or whatever. It's just about making music. And with 'Lucozade', I was feeling inspired – the lyrics were just a stream of consciousness. It was me at my most unedited. I had my lyric book with me and, for ages, I had been writing down ideas, not necessarily songs or lyrics but stuff I wanted to say. Once I hear a beat I like, I tend to pull out the book to see what I can take from it – a vocal or a groove – and then I'll mess about, rhyming words to fit the track. At first I'll just say it, but once I can feel the lyrics and harmonies locking together, I'll start to sing it until it's developed a proper melodic shape.

When I'd got the lyrics for 'Lucozade' in place, we got the song down in just one take. And that opening lyric – *'I'm sipping pink Lucozade / We're blazing on that new-found haze . . .'* came from the bottles I'd picked up for the guys earlier.

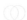

# SONG NOTES
# 'SHE DON'T LOVE ME'

This was another track we put together in XYZ's garden-shed studio. Alex described it as 'yacht rock', because it was up tempo but it had a classic sound. He wanted to make it more poppy by taking out some of the swearing, but I was like, 'No way, that's staying in.' I was adamant the lyrics weren't going to be changed: '*I think I know she don't love me / That's why I fuck around.*' I don't swear on a track just for the sake of it; sometimes, a swear word is the only one that will express what you want to say in the way you want to say it. I don't want to lose the power of what I'm trying to get across. When I'm writing, I play around with words all the time, and each one is weighed up and chosen for a reason.

I like the vibe in XYZ's studio. It's a lot of fun in there and, like 'Lucozade', the lyrics for 'She Don't Love Me' came out of me in a stream of consciousness. We were in there partying, getting drunk, and I would get into the beat and jump on the mic to sing various lyrics, just trying stuff out. I felt like I was performing rather than recording when I sang that song, and the whole track was very unedited. It was just really relaxing to play it really loud, sip a beer and get up and sing when the mood took me. That song picked up a great energy along the way.

# THE ALBUM

When I started writing *Mind of Mine*, I was finally writing for myself for the first time. At the beginning, in my head, I was just experimenting; nobody else was supposed to hear what I was coming up with. But once I got close to finishing everything, I started to get a bit worried. I was like, 'Shit, other people are going to hear all this stuff now . . .'

I also knew that some people were going to hold my new sound up in comparison to the stuff I'd been making with One Direction, even though it was completely different. People were going to set us up in some sort of head-to-head chart battle, but there was never any plan to get into any rivalry with the boys. There's no need. What we're doing is just not the same.

# MIND OF

# MINE

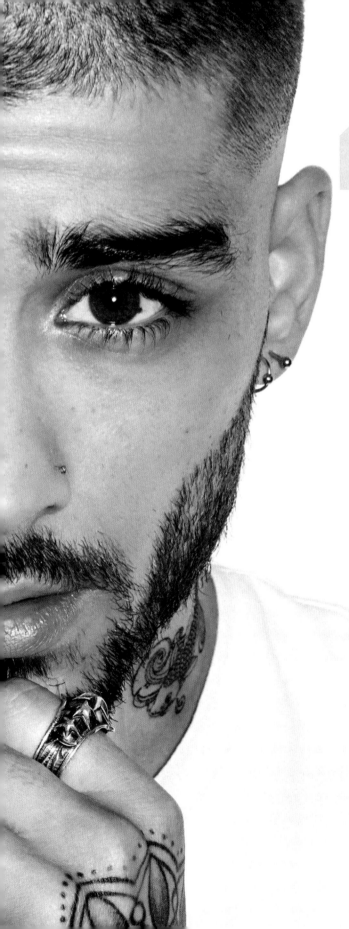

# MIND OF MINE

# TRACK LIST

- FOOL FOR YOU
- BORDERSZ
- TRUTH
- LUCOZADE
- TIO
- BLUE
- BRIGHT
- LIKE I WOULD
- SHE DON'T LOVE ME

# 'PILLOWTALK'

In January 2016 'Pillowtalk' was released, and the reaction from the fans blew me away. It was fucking insane, one of those crazy days I'll never forget. It was me and the people I work with most closely in this random hotel room in Paris. We stayed up all night, because 'Pillowtalk' was coming out at six in the morning in Paris and there was no way we were sleeping before that.

It got to six o'clock and it was released, and we all sat around this table in the hotel room, drinking and chatting and watching how it was doing in the charts. It just went up and up. Nadia would say, 'You're number one in twelve countries, and then she'd say, 'You're number one in twenty countries' – and then, 'You're number one in thirty-two countries.' At that point I ordered the most expensive bottle of champagne I could. We were so pumped. When we were all out on the balcony, just about to crack open the bottle, Nadia came out and said, 'You're number one in sixty-eight countries around the world.' It was just . . . well, one of those moments in life that you can't describe without sounding proper cheesy. It was magical. We went out and bought huge speakers and blared the song out so loud we were told to turn it down by the hotel. But we didn't care. We must have played 'Pillowtalk' fifty times that night.

I remember at one point I went out to join one of my team who was having a cigarette on the balcony. She just looked at me like, 'Fucking hell, what just happened?' Neither of us could believe it. She asked me how I felt and I didn't know how to even explain it. That day made me realize that there were still

people out there who wanted to listen to my music, who were still interested in what I was doing. We looked out across Paris, and she said to me, 'You've made it.' 'No, we've made it,' I said. 'Every person on the team has made this happen.' It was true. And it felt great.

I don't think there's a better feeling out there. In that moment right there, we knew what success felt like. That's what makes all the hard work worth it. I know my team had the same feeling, too, because they work so fucking hard. Times like that . . . I wish I could tell you about every second of that day. It's a really crazy, happy memory for all of us. That night, we all went out to a nightclub in Paris and a couple of my team went up to the DJ and requested 'Pillowtalk'. They played it in the club and we just went insane, like proper going for it. It was crazy to hear it in public for the first time like that. I felt so grateful to so many people that day. I'll never forget it.

With the single being as successful as it was, my brain had to process the fact that I'd taken a leap of faith in my professional life and it had paid off. I'm insanely thankful for the way things have worked out – I'm not

exaggerating when I say I feel really blessed – and it's been amazing to know that I have people who have supported me throughout, regardless of the decisions I've made in my career. I feel really strongly, though, that this is just the start. I'm not about to rest on my laurels just yet. Hopefully, those people will keep supporting me. And I'll keep trying to deserve their support.

I WAS ALWAYS HIGH
BECAUSE YOU DIDNT
LIKE
MY MOOD
SWITCHED
MAN FUCK
THIS BITCH
AND THESE
GAMES
IM GONE NOW
I GUESS
I SWITCHED LANES
AINT ONE TO
TALK ABOUT
MY INNER WAYS
I THOUGHT IT WAS
TIME LOST
BUT MY MINDS
GAINED NOW IM
INTO FRAMES
WITH NO PICTURES
SO I DONT FEEL IT
WHEN THE BITCHES/IMAGE
SWITCHES
TAKE NOTE

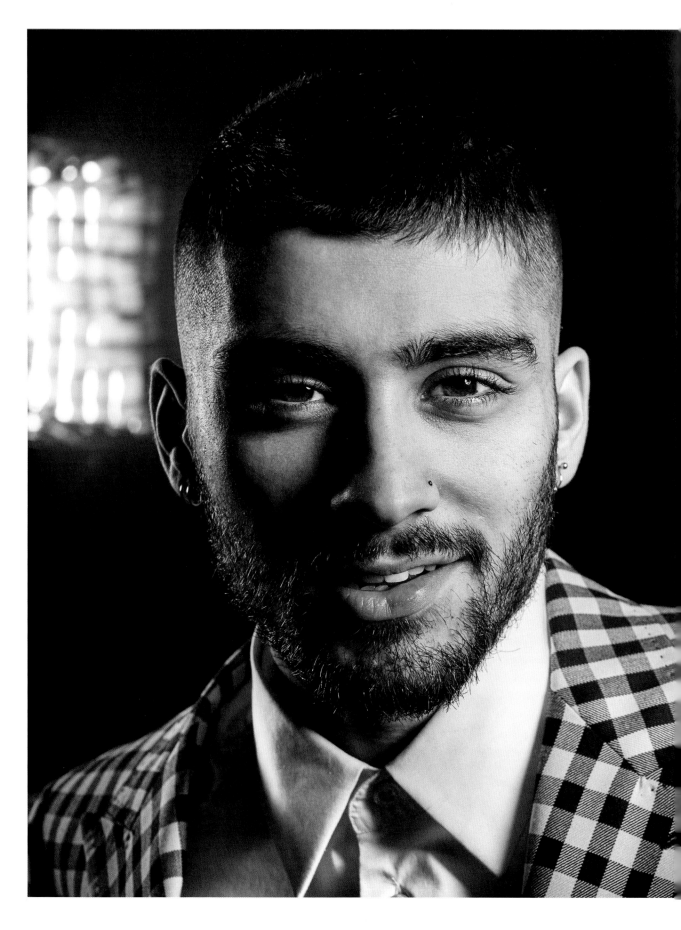

# ▢ POLAROID
# LYRIC SHEETS
# AND LYRIC BOOK

I'm always scribbling ideas for lyrics down in a notepad or on scraps of paper. I've still got all my songs, handwritten, on headed notepaper from the Beverly Hills Hotel or on one of those pads of yellow lined paper you see in office stationery cupboards. All the words express thoughts and musical ideas that come straight from me. The lyrics are real: they have to be if I'm going to be passionate about singing them. There's no point in writing it down otherwise. I'm not going to be able to sing somebody else's story with the same level of emotion. All the songs on *Mind of Mine* are personal to me. And yeah, every now and then, someone might publicly make an observation about my lyrics and what they think they mean and majorly miss the mark, which can hurt. But at the same time, they're entitled to their own interpretation, and also, my skin's about a hundred times thicker than it was when I first started out in this business. The unpleasant things that people say to me now generally just make me laugh. I'm being me now, and I make no apologies for that.

**The Beverly Hills Hotel**
and Bungalows
Dorchester *Collection*

Don't do it LI[crossed out]
Don't do it that way
I was only there yesterday
Might have been a diff age
Clocks turned but we
Learn the same

I didn't want u to feel it
I know that it's all a phase.

FATHER

9641 SUNSET BOULEVARD, BEVERLY HILLS, CALIFORNIA 90210
TEL +1 310 276 2251   FAX +1 310 887 2887   dorchestercollection.com

---

**The Beverly Hills Hotel**
and Bungalows
Dorchester *Collection*

SHE KNOWS How
I feel abat her
[scribbled out] Don't NEED to
HEAR it every DAY
I SHOW HER

EVERY WAY
[scribbled out] Don't NEED NO
WORDS to get in the
WAY

9641 SUNSET BOULEVARD, BEVERLY HILLS, CALIFORNIA 90210
TEL +1 310 276 2251   FAX +1 310 887 2887   dorchestercollection.com

---

**The Beverly Hills Hotel**
and Bungalows
Dorchester *Collection*

WOULD I DO
THINGS RIGHT
WHATS WOULD [crossed out]
[crossed out] [crossed out] MY MIND
SAY
COULD i see
WHATS IN Sight
Would i do my
WAY

9641 SUNSET BOULEVARD, BEVERLY HILLS, CALIFORNIA 90210
TEL +1 310 276 2251   FAX +1 310 887 2887   dorchestercollection.com

---

**The Beverly Hills Hotel**
and Bungalows
Dorchester *Collection*

How u want me to feel it?
when the story ain't mine.
How will I memorize it
when those aren't even my lines?
pre- Locked in compartments
The stories I have made
Lit in the darkness
The marquee of my brain

9641 SUNSET BOULEVARD, BEVERLY HILLS, CALIFORNIA 90210
TEL +1 310 276 2251   FAX +1 310 887 2887   dorchestercollection.com

   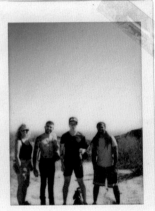

   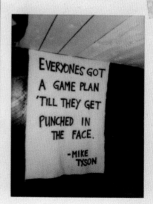

EVERYONES GOT
A GAME PLAN
'TILL THEY GET
PUNCHED IN
THE FACE.

-MIKE TYSON

WHEN I WOKE UP THIS
MORNING THE SUN HAD
JUST DANED AND SO DID
THIS THOUGT LIKE,
DID I SPEND ALL MY TIME
RIGHT, ~~scribbled out~~
I GOT, SEONE ALL TEM
BRIGHT LIGHS
IM NOT FOND OF it NOT
QUITE, NOT THE PLAN
FROM THE START
BUT THINGS FALL APART
AND IN A PART YOU
FEEL DISTANT REACTION ARE
~~CONSTANT~~, LETS SAY FOR
INSTANCE THAT YOU HAD A
CONCIOUS WOLD YOU HAVE
THE TIME THEN, TO VEUSIT
ON THE OPTION
~~THESAN~~ LIFES NOT
LOCKED IN, I KNOW YOU
HATE ME FOR SAYING
IT, BUT ITS A DIRTY
CAME AND WE BOTH KNOW
WHOS PLAYING ITS OLD SAYING
SAYS IF YOU MAKE A

## ◐ SONG NOTES
# 'REAR VIEW'

'Rear View' was a super-introspective song that I put together with Malay. It was pretty representative of what I was thinking at the time. We were working out of Larrabee Studios in LA, and I was telling Malay about how I was feeling about being independent. We discussed all the emotions that came with making a huge change in your life without knowing what might happen afterwards, like I'd done when I left One Direction. For me, it was this massive build-up of butterflies in my stomach: I was nervous, excited – everything. I told Malay I wanted a song where I was a man reflected in a mirror, talking to myself about what I'm doing and feeling. From there we built the track up.

◐

HEARD ABOUT ALL THE
THINGS YOU'VE DONE

AND ALL THE WARS THAT
YOU'VE BEEN IN

HEARD ABOUT ALL THE
LOVE YOU LOST

IT WAS OVER BEFORE
IT BEGAN

HEARD ABOUT ALL THE
MILES YOU'VE GONE

JUST TO START AGAIN.

# 06.

# MELODIES AND MEMORIES

'Whatever job you happen to be doing, to be respected by your peers, you only get that high level of credibility when people at the same level as you professionally are like, "Yeah, actually, you're pretty good."'

# MIND ⊙F MINE

When I'd finally finished recording *Mind of Mine*, I realized I had put down forty-eight songs. I couldn't believe we had so many. It was a nightmare choosing the final list, especially because all the songs meant a lot to me, and I procrastinated as much as I could before making my decision. In the end, it all came together; the songs chosen for the album spoke for themselves, even though everything was done at the eleventh hour. As anyone who's worked with me will tell you, I have a habit of taking it right to the wire when it comes to a deadline. But I got there in the end.

In the build-up to the release date, I struggled to relax. It was a weird tension where, because people had been so positive about 'Pillowtalk', I was feeling a bit more confident but, at the same time, I was really anxious. Not scared as such, but anxious. I was excited as well, though, to have the chance to show people what I was capable of vocally and to reveal all the musical inspirations I had found over the years — the stuff that had pushed me into being a musician in the first place. The album title was a clue to that. *Mind of Mine* was a mad brainstorm. It was a snapshot of the way I was thinking and feeling during a short period in my life, and it was time to release it to the world.

There was definitely a part of me that wanted to show the world I could actually sing. I had been part of a hugely successful pop group, but there was a bit of me that really wanted to prove, to myself more than anyone, that I was a credible artist in my own right, that I could make music and that I deserved to be here on the music scene just as much as all the guys who had been signed up in more traditional ways, after being spotted playing a gig in a bar or at a nightclub, or uploading a video on YouTube.

# USHER

I've always loved R&B. When I was a kid auditioning for *X Factor*, my song of choice was a track by Mario called 'Let Me Love You'. Usher was another R&B artist I've always loved, probably from when he released *Confessions* in 2004. That album had some really cool tracks on it, like 'Yeah!', 'Burn' and 'Confessions Part II'. 'Here I Stand' and 'Raymond v. Raymond' were also so sick. There were lots of different things I took from Usher, and also from R. Kelly, such as the way they sang certain words. I'd play their tunes over and over, but I never tried to rip them off – I'd always put my own spin on what it was they were doing. Chris Brown asked me to contribute vocals alongside Usher for his remix of 'Fuck You Back to Sleep', and it was insane to appear on a track with him.

I got into Usher because he's got a great tone and, I think, an incredible range. The melodies he comes up with are genius, and he delivers solidly every time on his albums.

I listen to all sorts of nineties R&B jams, sometimes stuff that hasn't had quite the same level of attention, like J. Holiday's music, for example. He's a singer and rapper who got a Grammy nomination for his single 'Bed' in 2007. But it's not just R&B I'm into. I'm into everything, and my tastes aren't that specific – in fact, they've got broader and broader as I've got older. I like Mariah Carey and Shania Twain; I like Johnny Cash and a lot of other country artists. My influences come from many places. As long as it's a good tune, I'm into it.

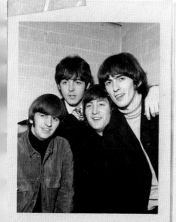   

## ⏱ SONG NOTES
# 'WRONG' (*FEAT. KEHLANI*)

Kehlani is an American R&B singer-songwriter who was in a band called Poplyfe – a group that had first made its name on *America's Got Talent*. I was a big fan of her albums, and when it came to writing 'Wrong', I knew I wanted to get her on it. Kehlani's singing is sick. I love her style – in fact, I remember wanting to write a song specifically so I could do a duet with her. I kept playing her stuff to the XYZ guys in the studio.

We met up in LA, and I played her a couple of songs. It didn't take long for her to tell me that she thought it was something she could be down with. The track 'Wrong' was originally written in the garden-shed studio, but we finished it off in LA. When the guys played me a dirty, dirgey beat, I was into it straight away. It fitted the mood of the song – it was rude, the lyrics were about the darker side of lust, and it had a really cool, laid-back tempo. I enjoyed the whole process of collaborating with Kehlani. It was great to have someone to bounce off like that. I reckon I'd like to do more collaborations in the future.

Part of the tension I was feeling around the release of *Mind of Mine* was definitely a build-up of excitement. Whenever I had released tracks or albums before, I had shared the buzz with the boys in the band. But with *Mind of Mine*, the anticipation was way more intense. I was buzzing. Not because I was super-confident – that type of indestructible self-belief just isn't me – but because I was desperate to discover once and for all if I was deluded about my ability to make a good record *on my own*. I wanted to hear what my fans thought. And, of course, I hoped that it would attract a new bunch of people who liked the music for what it was. It was kind of like that feeling you get in your stomach when you don't yet know if someone you really like feels the same way about you.

When *Mind of Mine* came out it went to number one in both the UK and the US, and I couldn't have been more psyched. That day was amazing. Just like the release of 'Pillowtalk', it's one of those days I'll never forget. My management team came round with this massive bunch of balloons in the shape of the number 1. Then a few of us went and had proper fish and chips at the Pikey, a British pub in LA. After that, we went out for drinks and just chilled. All our hard work had paid off. I felt like I could just be me, like people were realizing who I was, that they were appreciating my music and were interested in it. I was so happy that people still wanted to buy my music. I'd had no idea whether that would actually happen. It was a huge relief. My fans, family and friends had helped me to make that leap, and I'm insanely grateful to all of them. I had achieved what I set out to do with this first album and it had given my life new purpose. And I had learned so much and had a blast along the way. Having a number-one album was the crazy, happy result of being able to really push my creative limits, trusting that it would come off, and collaborating with awesome, talented people who encouraged, inspired and believed in me. You know who you are. Gratitude.

'HAVING A NUMBER-ONE ALBUM WAS THE CRAZY, HAPPY RESULT OF BEING ABLE TO REALLY PUSH MY CREATIVE LIMITS.'

'AS A SOLO ARTIST IN CHARGE OF MY OWN MUSIC AND IMAGE, I CAN DO WHATEVER THE FUCK I WANT.'

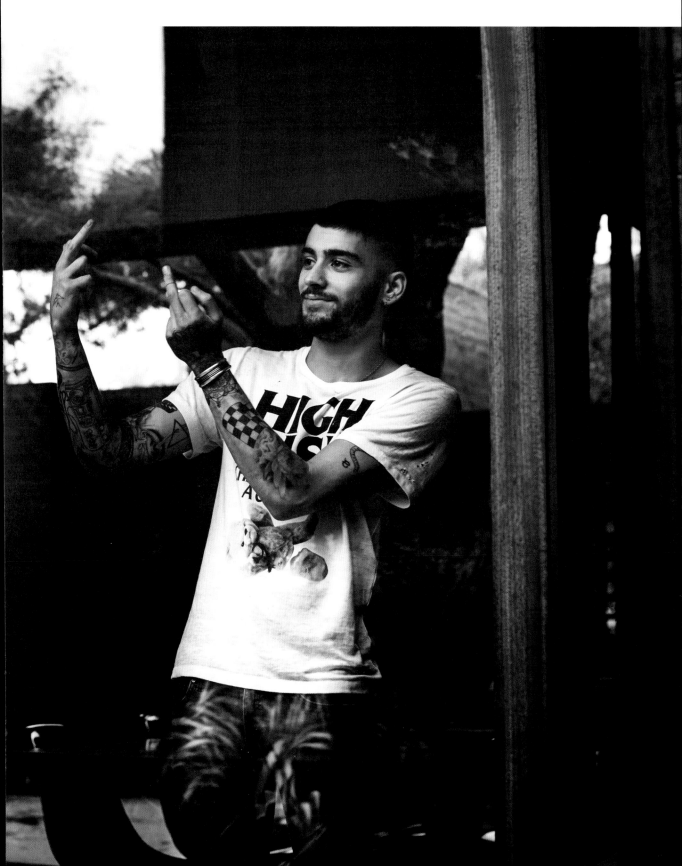

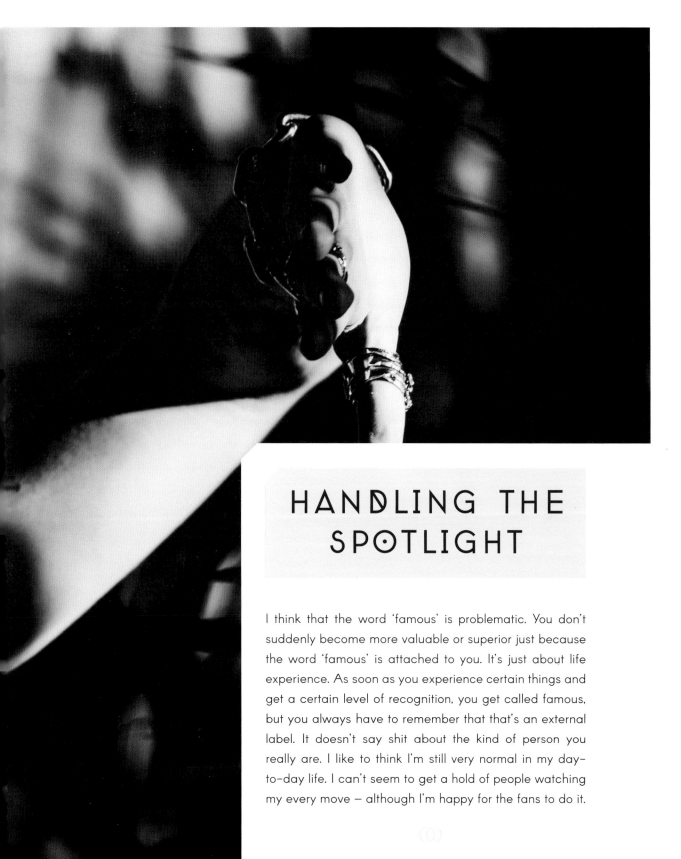

# HANDLING THE SPOTLIGHT

I think that the word 'famous' is problematic. You don't suddenly become more valuable or superior just because the word 'famous' is attached to you. It's just about life experience. As soon as you experience certain things and get a certain level of recognition, you get called famous, but you always have to remember that that's an external label. It doesn't say shit about the kind of person you really are. I like to think I'm still very normal in my day-to-day life. I can't seem to get a hold of people watching my every move — although I'm happy for the fans to do it.

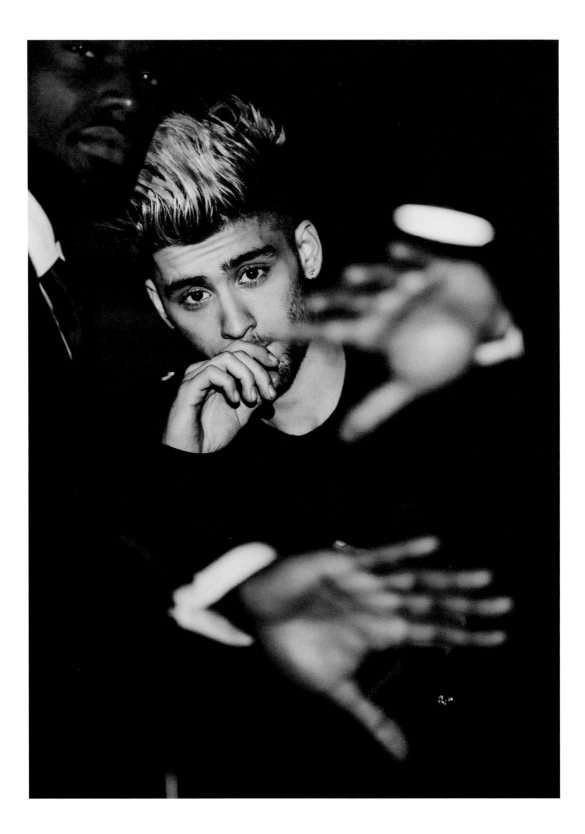

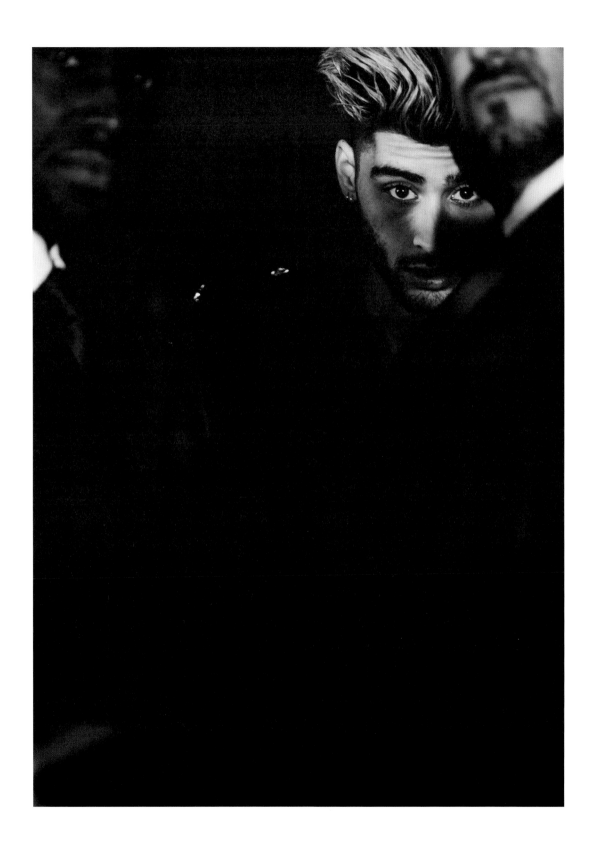

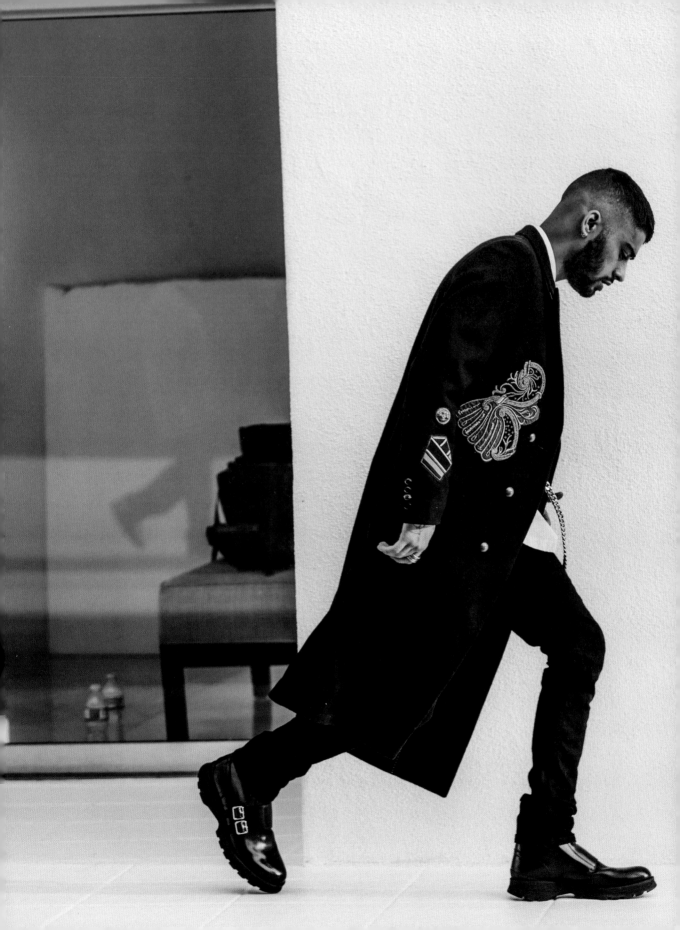

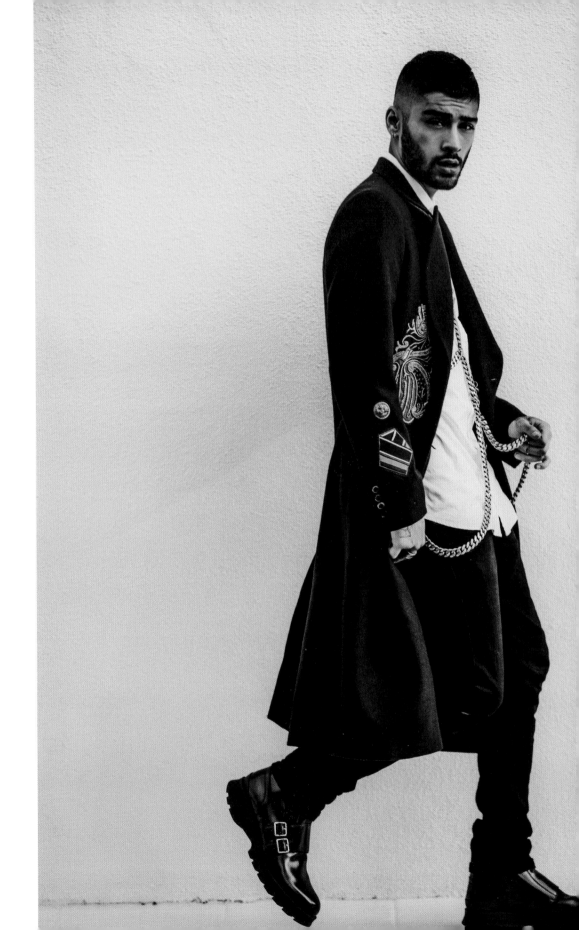

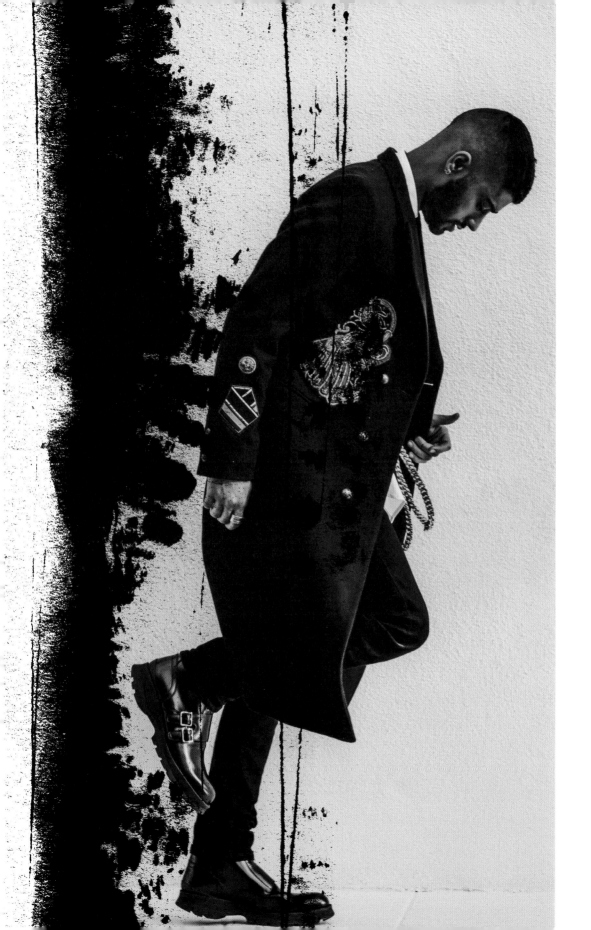

When I look back at the photos from the band days, I seem so different. Feeling how I feel now, I can hardly recognize that boy on *X Factor* and the teenager in One Direction as me at all. From the beginning of the band, I've been able to chart my life through photographs and TV clips. I basically morphed from a teenager to a young man in the public eye. There was no escaping that media attention. It was       full exposure. It is a cool thing, though, to have that portfolio of images now, showing me growing up, and I'll be able to look back on them when I get older. Hopefully, when I have kids, and then grandchildren, it will be something for them to enjoy looking at, too. Meanwhile, the changes I felt inside about everything that I experienced from the age of seventeen – when I first appeared on the telly – to now, are largely undocumented. I hope some of that is conveyed here. It's pretty hard to get it all down, but I hope that, after reading this book, you'll be able to relate more easily to how I feel about what happened in those years.

People often ask me whether growing up in the public eye is any different to growing up away from the limelight. Of course, in some ways it's totally different – if you're in the public eye, someone is always watching you. Media spotlight aside, though, I don't know whether it really is that different deep down, in the place where all of us are confronted with our insecurities and fears, our aspirations and dreams. On that level, growing up is probably just the same. We all suffer some sort of shit. The things that have kept me on track are the same ones that keep anyone on track – a good moral upbringing, knowing how to behave with other people and trying not to worry too much about anybody else's opinions.

## ☐ POLAROID
# GUITAR

I've got a lot of crazy stuff in my house — crossbows, Marvel comics signed by Stan Lee, flags, dirt bikes and a go-kart with a big 'Z' painted on the front. But of all my possessions, one thing has been a constant in my life for the past five years: my guitar.

I first started playing when I was eighteen. I wanted to learn an instrument to give me another means to express my music. I'm not that good; I just like to mess about and come up with melodies and stuff, and it definitely helps me when I'm writing new material.

You can get totally lost in the sound of a guitar, and I love that. The sound can have quite a soothing quality to it and, though I don't really listen to a lot of headline rock, I am a fan of great guitarists. I've been lucky enough to work up some guitar parts that later made it on to *Mind of Mine*. I got a riff on to 'Intermission: Flower'. When you listen to the track, maybe you can hear me playing away. After writing 'Flower', I was enjoying playing the guitar so much that I started to build up a bit of a guitar collection. I already had about five then, but that's doubled now. I bought a black graphite RainSong acoustic guitar, which I love — it's perfect for songwriting and recording. A lot of my time at home is spent strumming on my guitars and seeing what I come up with. When I find a melody I like, I record it as a voice note in my phone for my next studio session.

# ■ POLAROID
# GRAFFITI WALL

I've always been into my art, even when I was a kid. When I was five or six years old, I started drawing cartoon characters, like Casper the Friendly Ghost, all the superheroes and other comic-book characters, just scribbling away.

When we first started out in the band, somebody produced a video where I'm talking the fans through my doodles of the band. Then I had to draw a portrait of Christine Bleakley, which was a bit of a laugh. Later on, I would make graffiti murals backstage. Whenever we played in arenas, there were always large rooms just lying empty backstage, so I would put up a huge piece of paper and make murals to kill the hours between soundchecks and show time.

Once I'd bought my own place in London, I decided to dedicate one room to graffiti. I figured that I could never do this at Mum's house in Bradford – but there's no reason I couldn't do it in mine. I loved painting in that place, and there was some really cool shit on the walls. I painted this massive Space Jam character on one wall – it was sick.

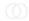

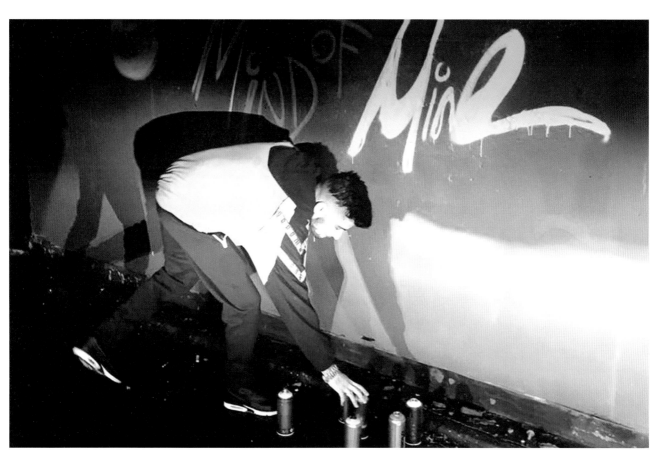

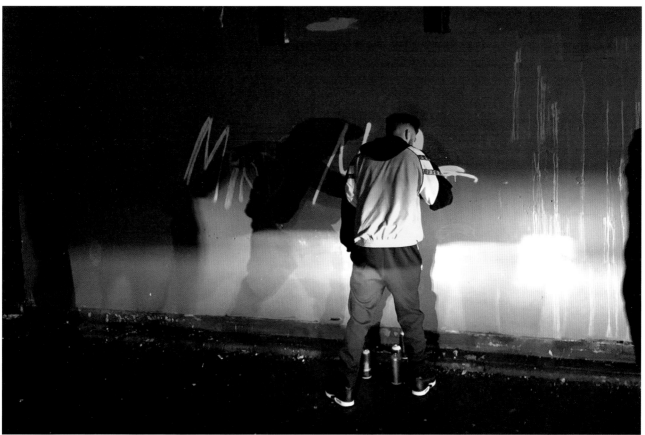

# 07.

# NOW I'M ON THE EDGE

'I'm no stranger to anxiety . . . A lot of performers suffer from it in one shape or form, whether they're in a band, are an actor, an athlete, whatever.'

———————————————————

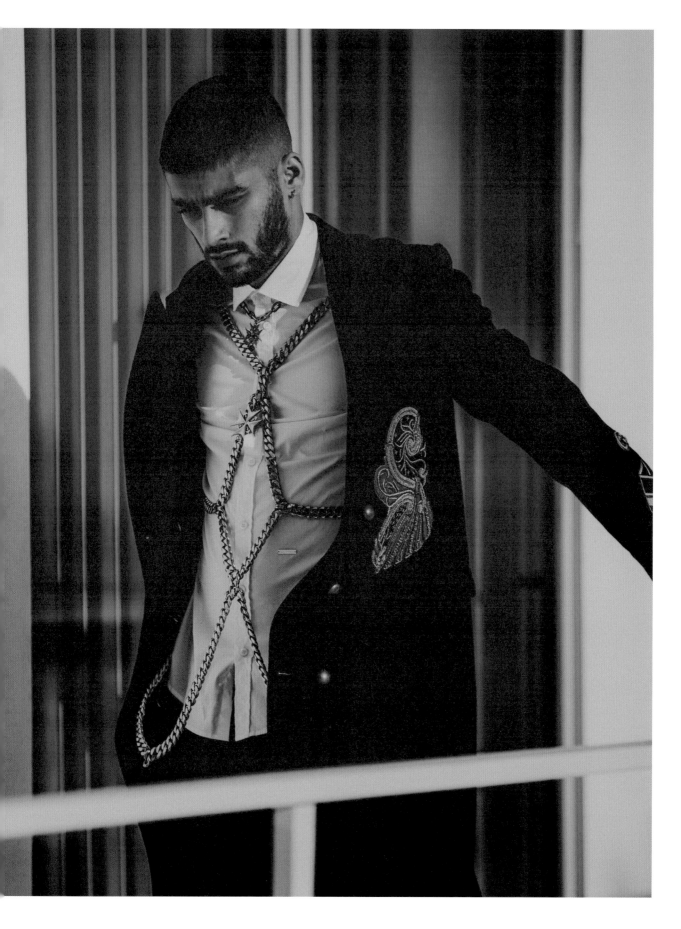

'THERE WOULD BE A MOMENT DURING
EVERY SHOW WHERE ANY FEAR WOULD BE
DROWNED OUT BY THE ADRENALINE OF
PERFORMING; I WOULD BE RIFFING,
FEEDING OFF THE CROWD, AND THAT
WOULD HELP ME BREAK THROUGH
ANY BARRIERS OF SELF-DOUBT.'

On the morning of the 2016 Capital Radio Summertime Ball, an anxiety attack hit me like a fucking freight train. I felt sick. I couldn't breathe. And one thought just wouldn't stop going around my head, over and over and over: *I've gotta play Wembley Stadium. I've gotta play Wembley Stadium. On my own.* The idea of it totally freaked me out and I was paralysed with anxiety.

I had played shows with One Direction at Wembley before, but then I was part of a gang, one of five lads singing onstage, and I always enjoyed the buzz. There would be a moment during every show where any fear would be drowned out by the adrenaline of performing; I would be riffing, feeding off the crowd, and that would help me break through any barriers of self-doubt. When I'm onstage I can become somebody else, a different guy entirely, a genuine performer. But getting there can be difficult. I was very aware that this time at Wembley I would be on my own, and my set was part of a crazy bill featuring some of the biggest names in pop. It was my first ever solo gig on UK soil, and in front of eighty thousand people.

# ANXIETY

I'm no stranger to anxiety and, for the most part, I like to think I've learned to cope with it. A lot of performers suffer from it in some shape or form, whether they're in a band, are an actor, an athlete, whatever. With One Direction, my anxiety generally surfaced when press intrusion into my personal life was in full force, but it wasn't always too bad. When it came to stepping onstage to perform, I'm a perfectionist, so glitches with a mic or problems with my earpiece would throw me off. I wouldn't have an anxiety attack, though, as I'd get my head around it . . . I had to, with us doing all those tours. But when it came to working as a solo performer, the pressure was magnified a million times over, because all the focus would be on me. This was a new experience, and I needed to adapt mentally.

*Am I good enough? Can I do this on my own? Am I gonna look like an idiot if I get up there?*

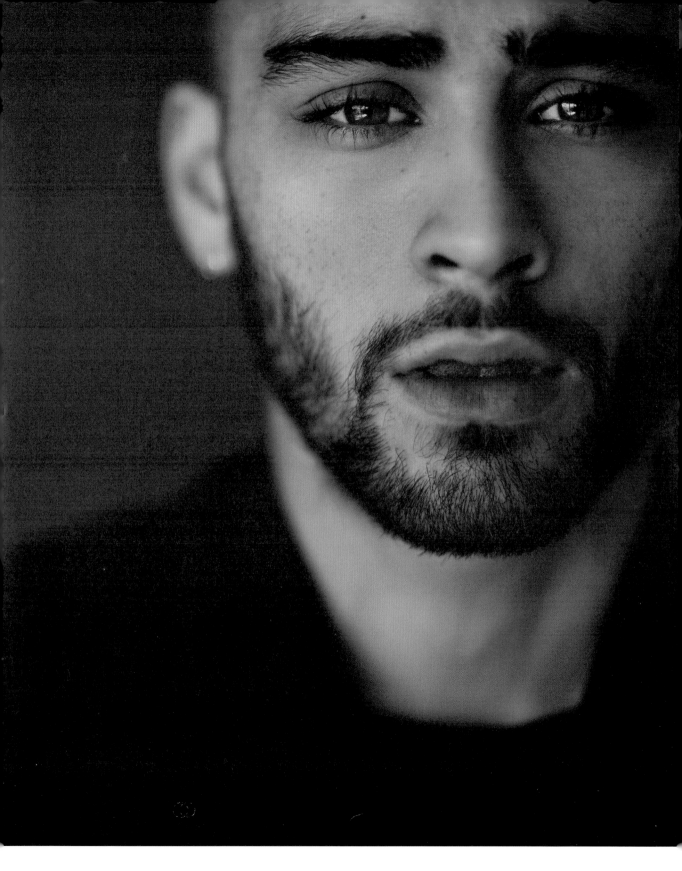

Even with all the crazy exhilaration around the album release, even amidst all my excitement and happiness, I still had moments of self-doubt. Probably one of the worst experiences of anxiety I had pre-Wembley was in the lead-up to the iHeartRadio Music Awards in LA, not long after the album was released. I'd got myself into this headspace where I was just like, 'No way. I can't do it. I'm not doing it.' Out of nowhere, I felt totally paralysed. My whole team came around to the house. They were trying to shake me out of it, but, for the longest time, I just couldn't see how I was going to do it. Then something clicked, and about thirty minutes before the show I managed to break through that wall, or whatever it was, and I did it. I felt sick. I was vomiting backstage before the performance, but I remember coming off after singing feeling so elated. It was so awesome playing that gig, the crowd was so supportive and it was like a huge victory for me: I hadn't let my anxiety get the better of me; I'd done it. That was probably one of the best nights I've had in LA. I needed that to happen again for Wembley, I needed to get myself onstage because I knew once I was on, I would enjoy it. But anxiety doesn't work in a rational way.

> 'I JUST WANT TO SHOW THE PUBLIC WHAT IT IS THAT I WANT TO DO – WHO I AM AS AN ARTIST – BUT SOMETIMES I PUT TOO MUCH PRESSURE ON MYSELF, AND THAT'S WHEN THE ANXIETY TAKES OVER.'

The only way I can explain the anxiety I experience is that there's a certain level of expectation I put on myself, and a certain level of expectation I feel from the fan base and the public. To transition into something else and do something different is always difficult for any artist. I just want to show the public what it is that I want to do – who I am as an artist – but sometimes I put too much pressure on myself, and that's when the anxiety takes over. I don't want to release something unless I feel that it really is the right thing to put out to people. So when I don't do what I'm supposed to, it's not because I'm disrespecting their investment in me, it's because I respect what they've invested in me so highly I don't want to let them down by giving them something that's second rate and shit.

I take my craft seriously. I don't want to just go onstage and dick about, I want to give the best performance I can. I love what I do. That's what I want people to understand. I love performing, and I love making music. I love it so much that it sometimes affects my health. Even if I rehearse a million times, sometimes I still just don't have that confidence.

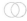

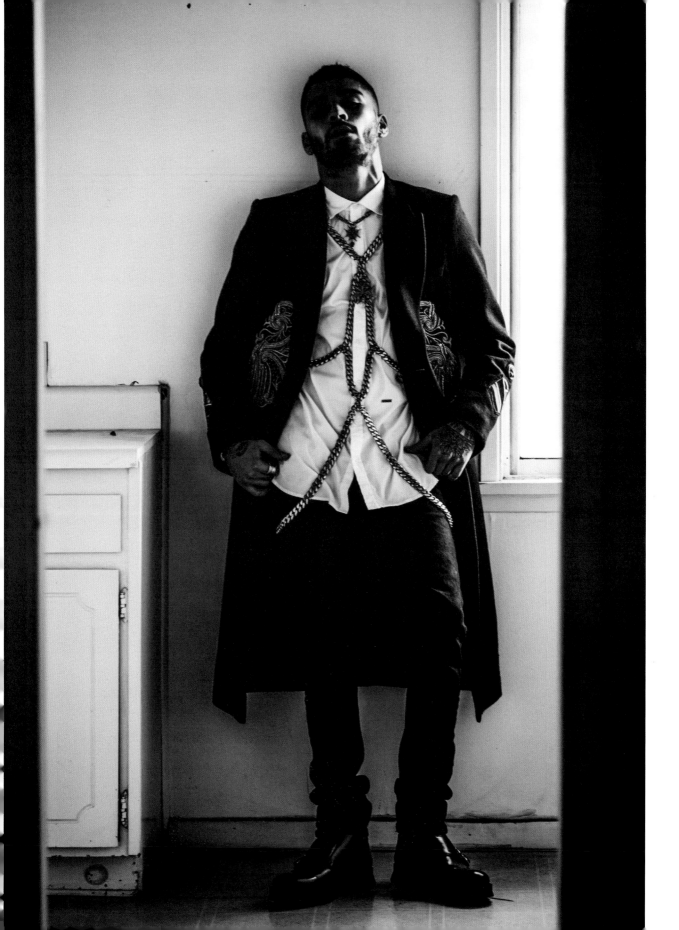

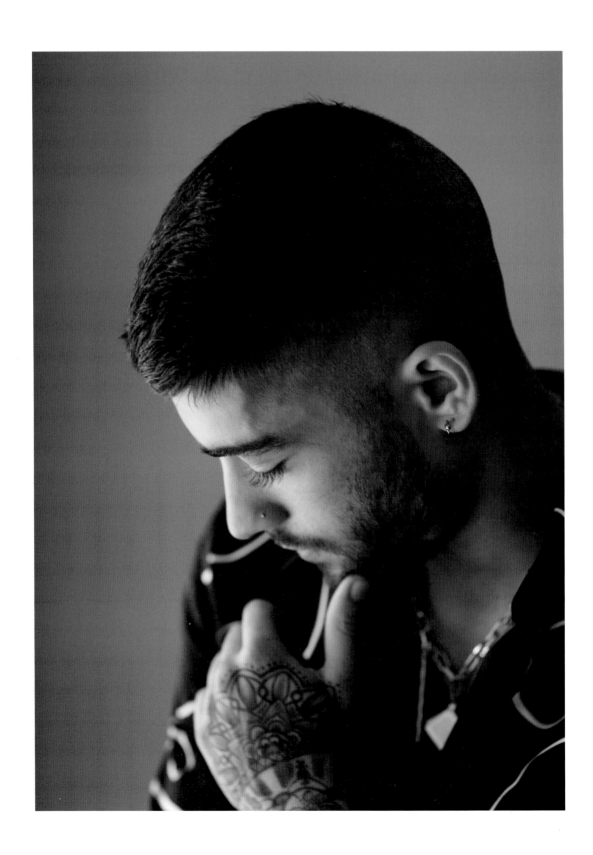

One of my managers asked me recently how I could still suffer from a lack of confidence after so long. Her point was something like this: that if I see however many fans showing support for me, giving me praise and saying that I'm good at what I do, then doesn't that mean that I must be good? Wouldn't I see that and have enough reason to be confident? My answer to her was no, not really. You might think it would be the case, but I've never been someone who can find positive validation from other people's opinions. It's great to have support, don't get me wrong, but if I feel like I gave a bad performance, it doesn't matter how many people tell me otherwise, I know it in myself. My sense of self-worth comes from my own judgement. It always has and I imagine it probably always will, for better or for worse. It also means that if I know I've done something well, and somebody else tells me it's shit, I just think, 'Fuck them'. I've never understood how you can base your own opinion of yourself on what other people think of you. It's hard to explain though, because it's not the same as not caring what people think, there's a subtle but important difference. I care about giving people a good performance and about them enjoying the show, I just can't be persuaded that my performance was any good if I know it wasn't. I'm stubborn like that. It's something I find difficult to explain.

I've generally found that if, like me, you don't always explain yourself, if you don't do interviews, some people interpret this to mean you're too cocky to give a fuck. That couldn't be further from the truth. I think a lot of the anxiety you see in me, that's just me not being aware – or maybe being too aware – of what it is that people want from me. I'm just trying to be honest, trying to be who I am. At times it feels as though people want me to be something else, but that's not a way I can live my life. I don't want to be some guy behind dark glasses, I want to be truthful, I want to be authentic. I'm still trying to figure out how to do that. But I think I'm getting there.

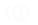

So far, I'd always managed to pull myself out of my anxiety attacks. I'd find the strength to psych myself up. Sometimes, something random would get me through it, like the time when I felt so sick with nerves I nearly pulled out of iHeart in New York on the day *Mind of Mine* was being released. A member of my team showed me a picture of the fans camped outside, the same fans I had sent doughnuts and coffee to the night before, and I just knew I had to do it, for them, if not for me. I had to convince myself to be a performer. That process is always difficult, it doesn't come naturally to me, but I usually find enough mental strength to get myself onstage and somehow overcome the anxiety, and let that performing guy takeover.

Unfortunately Wembley was different. I think that, despite my own philosophy about never giving a fuck about other people's opinions, I was really worried about how the audience would respond to me, that the people in the stadium wouldn't enjoy my performance. Even though the response I'd had to my new music had been mainly positive, there were so many bands playing, and such a wide range of fans. When we played as One Direction, it was our show, so we knew that the audience were there to see us. You'd feel pretty sure that they were going to give you a positive response even if you did make a mistake or do something stupid. But this was something else. For all I knew, every person in that audience was there to see someone who wasn't me. I panicked that people would be thinking, 'Who the fuck does that Zayn Malik think he is?' Especially after that press statement about me wanting to be a 'normal twenty-two-year-old'. I had a real mental block about the whole thing. Wembley suddenly became this huge obstacle in my mind, and I couldn't see a way of overcoming it. It was my first performance in my home country as a solo artist, and it just felt so fucking huge.

# WALLS CLOSING IN

The day had started out so well. I had been feeling super-excited. My family had all come over to my house in a massive group – my mum, all my sisters and my aunts – and took over the entire place to get ready. Between them, they used every mirror in the house to put on their make-up and do their hair, and there was a real party vibe going on. We had tunes blaring; it was as if everybody was getting ready for a wedding rather than a gig. I'd been getting my head around doing the show. I knew I was going to play three songs – 'Pillowtalk', 'Like I Would' and 'It's You'. But I also wanted to do 'BeFoUr'. I figured that if I was playing a show as big as Wembley Stadium, then I wanted to give my fans as much of a performance as possible. I was so determined to make it happen. My family set off around twelve thirty, and I decided to rest for a couple of hours, so I went back to bed. Bad move. When I woke up, it felt like the walls were closing in on me.

This overwhelming fear just kicked in out of nowhere, bringing with it a shitstorm of self-doubt. I questioned whether I was good enough to play that size of venue on my own. I tried to reassure myself with the fact that *Mind of Mine* and 'Pillowtalk' had done well in the charts, and that I had the support of my friends and family, too, but I was completely unnerved. I had no idea how I was going to get up onstage and perform.

A recent performance in New York was also weighing down on me. I had been asked to make a presentation to the Louis Vuitton designer Kim Jones at an event, but when it came to reading out my speech I stumbled over the script. I couldn't say the word

'innovative' without tripping up and, afterwards, I couldn't get that cock-up out of my head. If I just had to sing, maybe it wouldn't have been so bad, but it's those bits in between, speaking to the crowd and all that shit, being the perfect entertainer. That's not something I've ever been good at. At the same time, I know I can't just go out and sing and not say anything to the fans, because then people will just assume I'm an arrogant dick. But what the hell was I supposed to say to eighty thousand people? By this point, I was in a really bad place, and nothing could snap me out of it.

I went into my homemade pub – the shed in my back garden – looking for some sanctuary. I always feel safe in there. I can have a drink, chill, look at my old 1D stuff and feel close to my grandparents. But today, not even that could break me out of my anxiety. When my management team came over to see what was wrong, I was on total psychological lockdown. I would make a move to walk out of the house, to get into a car that would then drive me to Wembley, but I could only manage a few paces before I hit an imaginary wall. It stopped me in my tracks, and I would have to sit down again. I thought of all the fans who would have bought tickets to see me, and I felt sick with guilt – I knew how expensive the tickets were and the efforts they'd gone to to get them. Time was slipping away and there were lots people counting on me showing up, which only added to the pressure. But I just couldn't go through with it. Mentally, the anxiety had won. Physically, I knew I couldn't function. I would have to pull out.

'I HAD THE SUPPORT OF MY FRIENDS AND FAMILY, TOO, BUT I WAS COMPLETELY UNNERVED. I HAD NO IDEA HOW I WAS GOING TO GET UP ONSTAGE AND PERFORM.'

# TELL THE TRUTH

One of my team offered to write a statement saying that I'd been taken ill, but I didn't want to do that. I was done with putting out statements that masked what was really going on. I wanted to tell the truth. Anxiety is nothing to be ashamed of; it affects millions of people every day. I know I have fans out there who have been through this kind of thing, too, and I wanted to be honest for their sake, if nothing else. When I was in One Direction, my anxiety issues were huge but, within the safety net of the band, they were at least manageable. As a solo performer, I felt much more exposed, and the psychological stress of performing had just got too much for me to handle – at that moment, at least. Rather than hiding away, sugar-coating it, I knew I had to to put it all out there.

'I'm gonna tell them the truth,' I said. 'I don't want to say I'm sick. I want to tell people what's going on, and I'm not gonna be ashamed of what's happening.' My team were really supportive of my decision, and they agreed that, at this point, our best option was to be honest. That was refreshing, and it made me feel a bit more confident about putting out the statement. This is what it said:

**To all those people who have been waiting to see me perform at the Capital Summertime Ball today. I flew into the UK last night to appear in my home country in front of my family, friends and, most importantly, my UK fans.**

**Unfortunately, anxiety, which has haunted me throughout the last few months around live performances has got the better of me . . . with the magnitude of the event, I have suffered the worst anxiety of my career.**

**I cannot apologize enough, but I want to be honest with everyone who has patiently waited to see me. I promise I will do my best to make this up to everybody I've let down today.**

**I know those who suffer from anxiety will understand, and I hope those who don't can empathize with my situation.**

Of course, this opened up an insane amount of speculation. All sorts of stories were flying around afterwards. All I'd say is: always take everything you read online with a pinch of salt.

I found it really frustrating that, even now that I was being upfront about what the issue was, some people still found reasons to doubt it. But that's the industry. It's an aspect of this job that I have to deal with, and I'm trying to accept it. The thing is, I love performing. I love the buzz. I don't want to do any other job. That's why my anxiety is so upsetting and difficult to explain. It's this thing that swells up and blocks out your rational thought processes. Even when you know you want to do something, know that it will be good for you, that you'll enjoy it when you're doing it, the anxiety is telling you a different story. It's a constant battle within yourself.

After I put out that statement I was blown away by just how many people got in contact, and how many people suffer from anxiety. It's so common, and that's not surprising, really. Life bombards us with pressure – Twitter, Facebook, Instagram . . . Everywhere online there are unattainable body images that make us feel inadequate; competitive messages that bring us down; there's pressure from our parents and our peers to excel – pressure everywhere. When that pressure is magnified by living your life in the limelight, it can be pretty tough to handle: there's a lot of negative chat and hate out there. But what I found in the wake of my cancellation at Wembley wasn't hate but a massive amount of support from fans – people who understood, kids who were in the exact same situation as I was. Guys on Twitter were telling me how anxiety had affected their lives and saying that they were glad I had spoken up. It felt as though some good had come from the situation.

# 08.

# TIME FOR ME TO MOVE UP

'I make music for me, and that's not going to change. Commercial success has been an awesome reward, but the biggest challenge for me was to get myself out there by making music I truly love.'

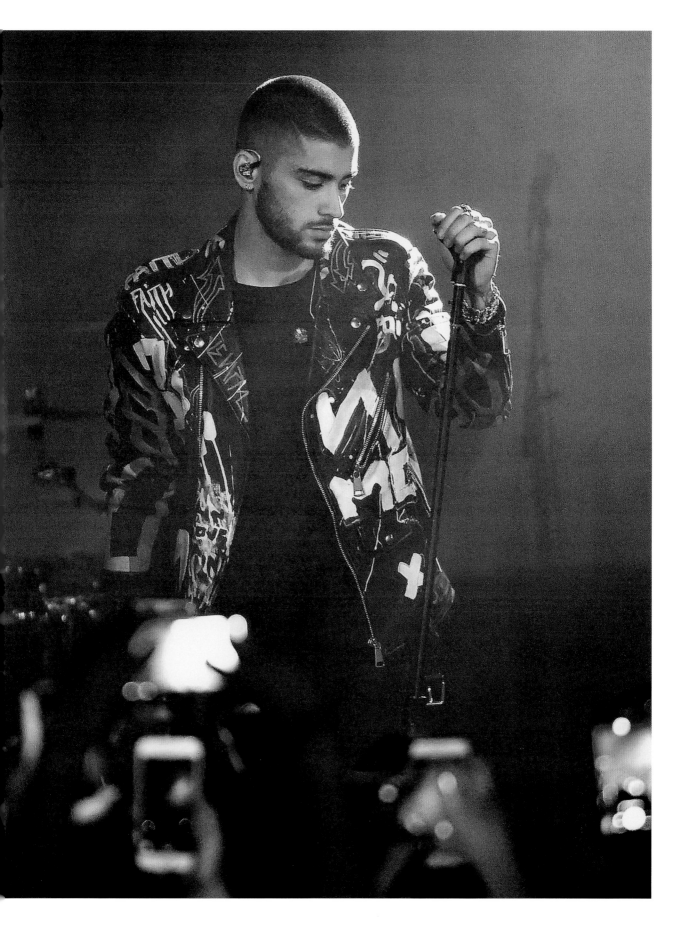

So, what's next? Well, even as I've been putting this book together, I've been writing material for my second album, though I've no idea yet when it will come out or what it's going to sound like. Now I'm in control of my own time and my own output, I'm not so bothered by that, and it's good to let things happen at their own pace. This is definitely still the beginning for me. I'm only in my early twenties, and I'm ready to take life as it comes.

I've been working on some material for a soundtrack, too – that's something else I'd really like to get more into. I couldn't believe it when I got a call in May 2016 from Baz Luhrmann, the producer of amazing films like *Romeo + Juliet*, *Moulin Rouge* and *The Great Gatsby*. He was putting together a TV show called *The Get Down*, a 'mythic saga of how New York's bankruptcy gave birth to hip hop, punk and disco'. It sounds sick. He asked me if I wanted to contribute a song to the soundtrack, and I was totally into the idea.

Because the track had to sound like it had been written in the seventies, it put a bit of a different spin on how I'd normally approach writing. The series was going to focus on the beginnings of rap, when guys like Grandmaster Flash were taking disco records and spinning the breakbeats. The music was locked into that time era, but at the same time it also sounded pretty modern. We based the track on an old Teddy Pendergrass song and fused it into a ballad a bit like 'It's You'. It was a lot of fun to put together.

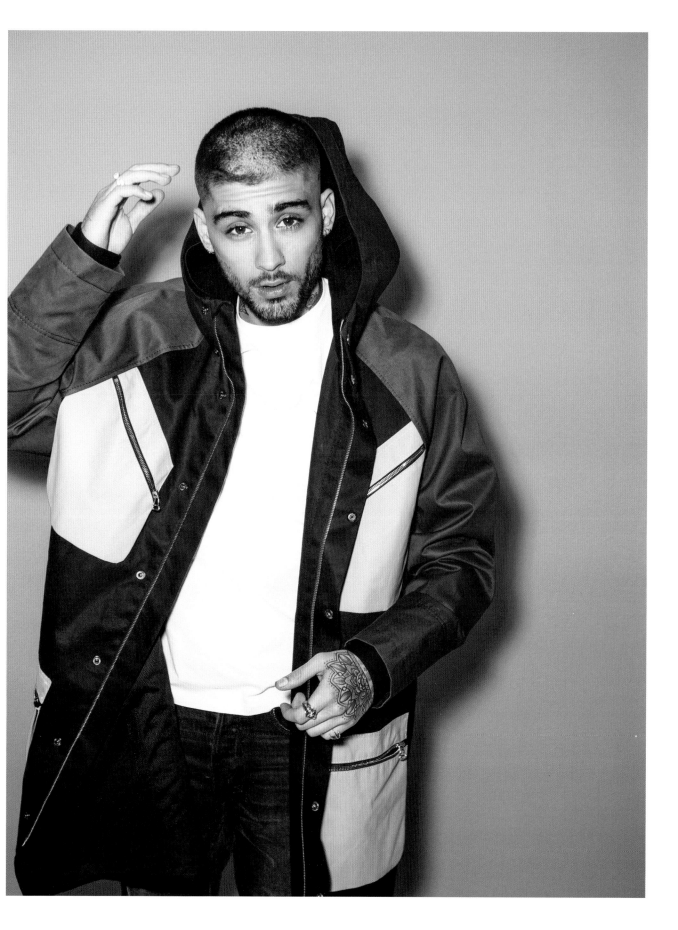

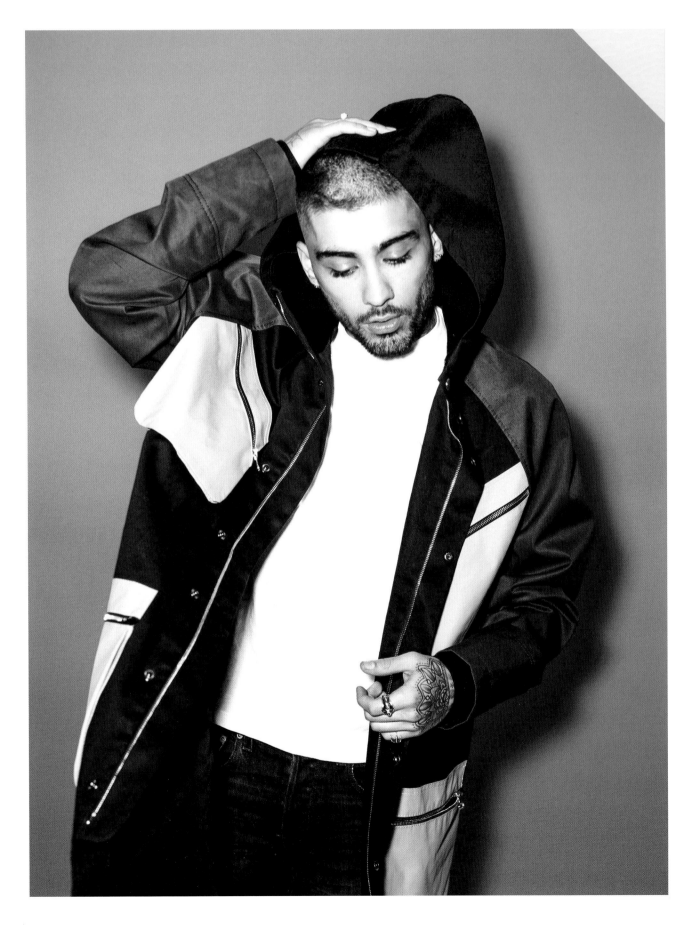

I'd love to work with Malay again in the future. I know that I'll be calling on him when it comes to putting together my second record, and on XYZ and MYKL, too. All those guys were amazing. I was blessed to find them in the first place. Making the next solo album's going to be a weird experience because, with the first one, the plan had just been to get some tracks together for a laugh, and I had zero expectations about what would happen when it was released. In the end, I found producers and self-financed the making of the record before I was signed to RCA. It's great to have that label support but, for the first album, doing it off my own back, that felt like a big achievement. Next time around, people are going to have their own expectations of me, especially after the insane response to 'Pillowtalk' – I feel like the pressure's dialled up way more now. But my attitude is pretty relaxed. I make music for me, and that's not going to change. Commercial success has been an awesome reward, but the biggest challenge was to get myself out there by making music I truly love. And now that I can do that, I'm much happier.

Things at the moment are good. My life in LA is pretty cool. I get up, hang out with friends at home, maybe do a little painting or collage-making in the house. I love to cook. My mum has sent me all her spices from home so that I can make curries. Music, whether I'm making it or listening to other artists, is always a huge part of the day. I'll be listening to my jukebox or record player all day and then I'll go into the studio at night. On a good day, I'll get a bunch of ideas down. And I'm still always writing lyrics in my book, or on my phone, wherever I am.

# WHAT IF...?

People have asked me in the past what I'd be doing now if I hadn't been making my own music. What if . . . ? Most of the time, I tell them that I would have become a songwriter for other artists, or a studio producer like Malay – something that kept me away from the limelight. But it would also be cool to go back to university to study English. Believe it or not, I actually did pretty well academically at school, despite being a bit of an idiot in other areas. I was pulled out of education after my GCSEs, but I've always wanted to take my A-levels and go on to do a degree. That was always my plan when I was a kid, before *X Factor* and One Direction ever happened: to go to university and study English. And I'd love to see it through. Maybe I could do a course from home – either in London or LA – and I reckon graduating would feel just as big a personal achievement as releasing an album or performing on tour. I think I'd get a lot of satisfaction out of doing that. I love reading, and I think an education is one of the most important things you can have.

But for now, I just aspire to continue making music, without worrying about how it sells. And I would like to get on the road and tour the world with it sometime in the future.

The one thing I need to do now is to get over my anxiety issues, and that's something I'm determined to work on. I'm on my way. Identifying my stumbling blocks has always helped me overcome them. But I haven't been asking Adele for help, like some of the papers reported after the Wembley show!

I don't have any regrets after talking about it, though. Maybe some people would have pretended to have been ill, but I didn't want that – my fans deserve better. They deserve honesty. Talking about it has given me the power to move forward and stop my anxiety from being this massive debilitating force in my life. I'd never feel sorry for myself because of it. I have no reason to. I know that once I break through the anxiety barrier, it's going to feel amazing, and I'm going to be able to perform the biggest shows, because that's where I want to be: I want to be able to headline Wembley. It will be nice if some folks show up to see it.

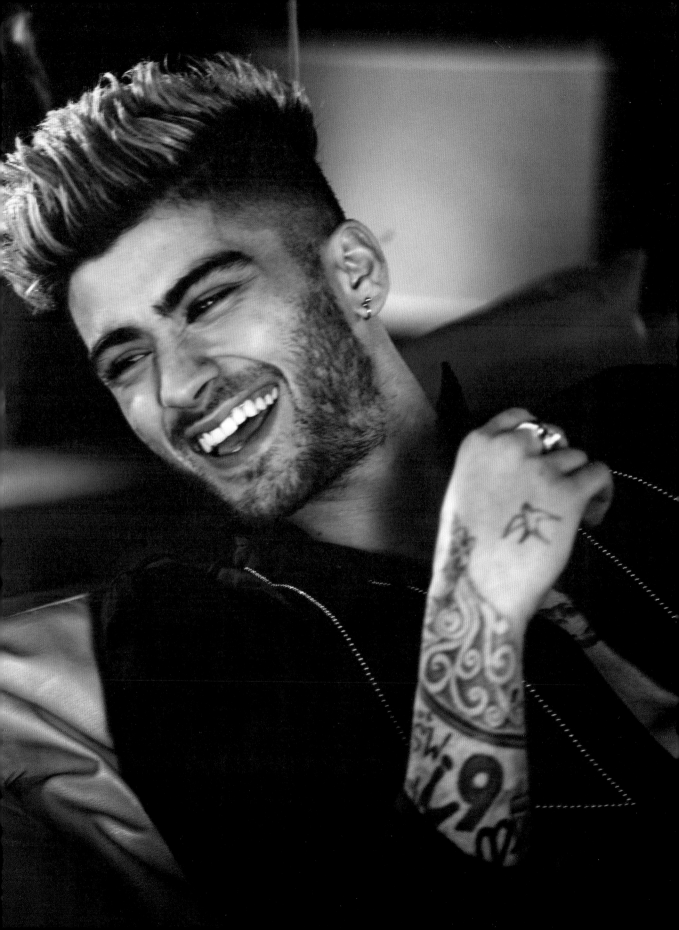

# GOD WILLING –
# INSHALLAH

But I've learned that I can't run before I can walk. I've got to be patient with myself. The plan is to start performing smaller venues and work my way up from there. Then, hopefully, I'll hit the big ones with more confidence. This anxiety isn't going to get the better of me. I want to play live. I *will* play live. And when I do, I want to give everybody the greatest show I can.

If I can be remembered as the guy who did what he wanted to do, not what other people wanted him to do and if I can remain authentic to what I believe in, I *will* consider myself successful. Success can't be measured by other people's judgements. It's not about records bought and tickets sold. For me it's about doing something which I can look back on and say that was worth my time to do. As long as I can keep making music I'm proud of, I know I'll be happy. And even if I'm not, I'll do it anyway. It's in my blood.

Thanks for supporting me.

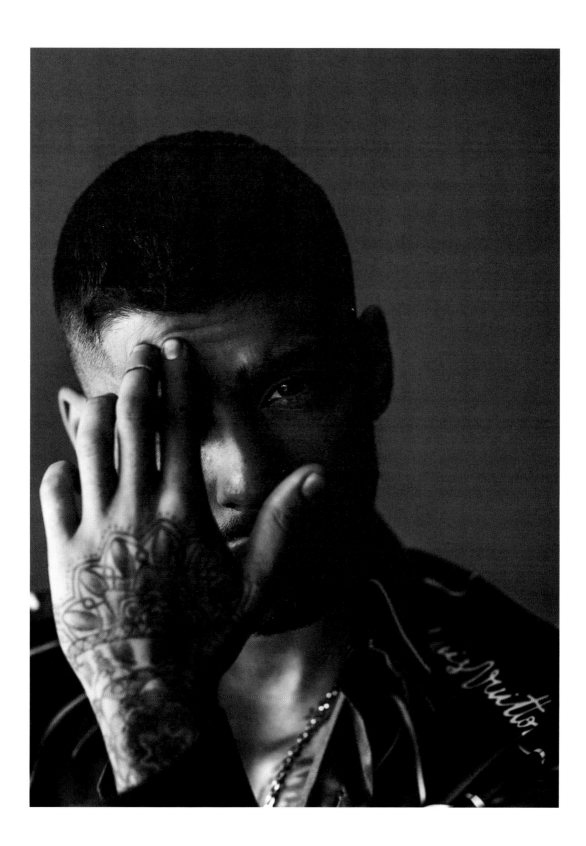

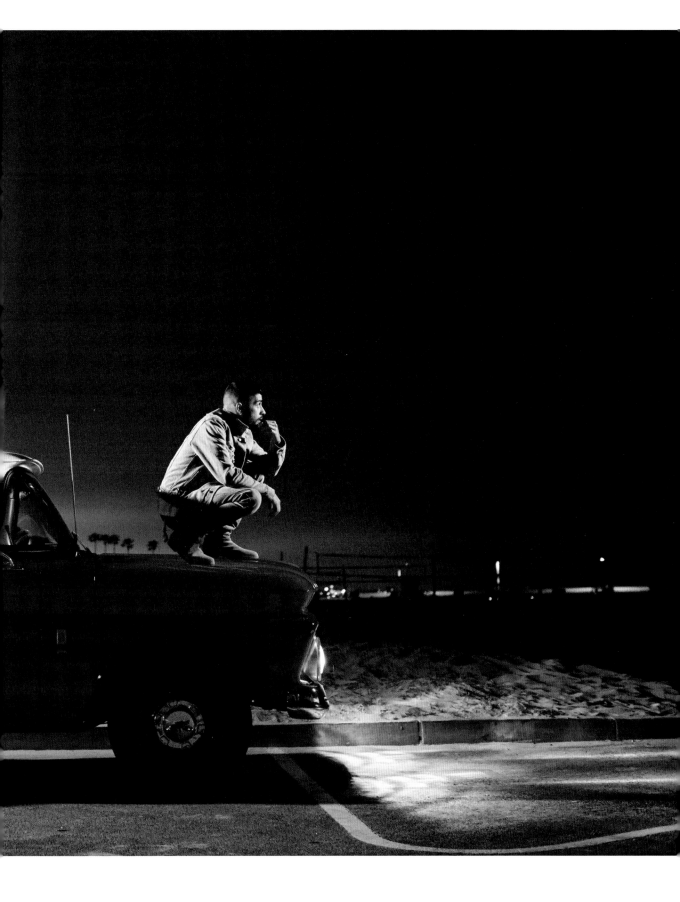

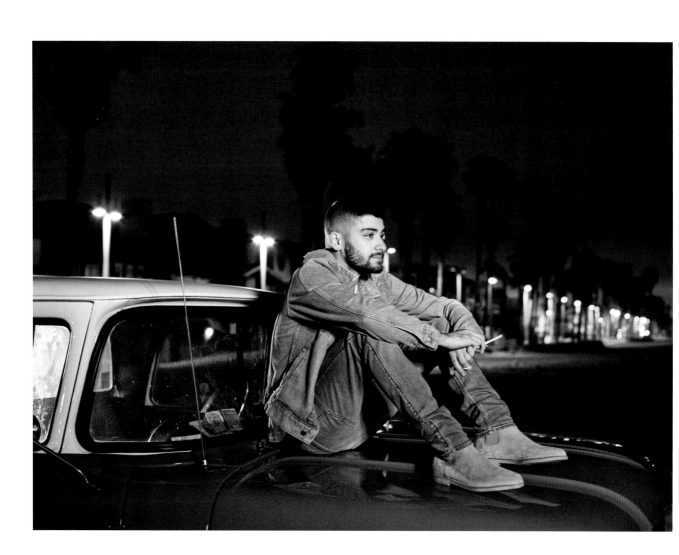

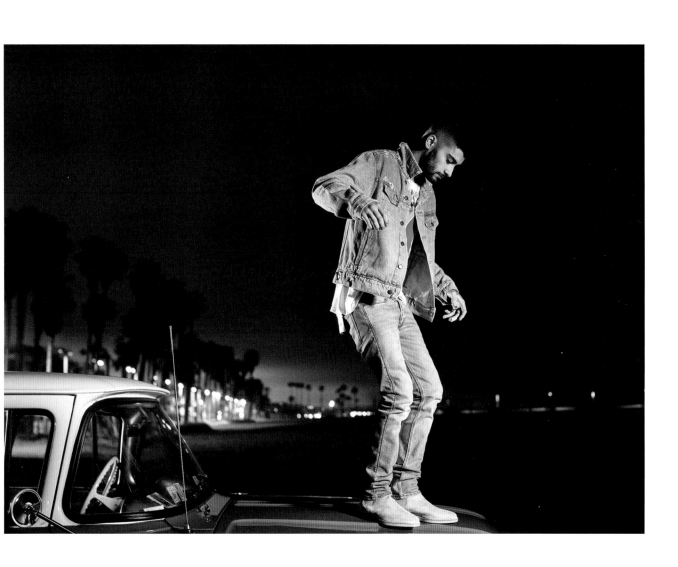

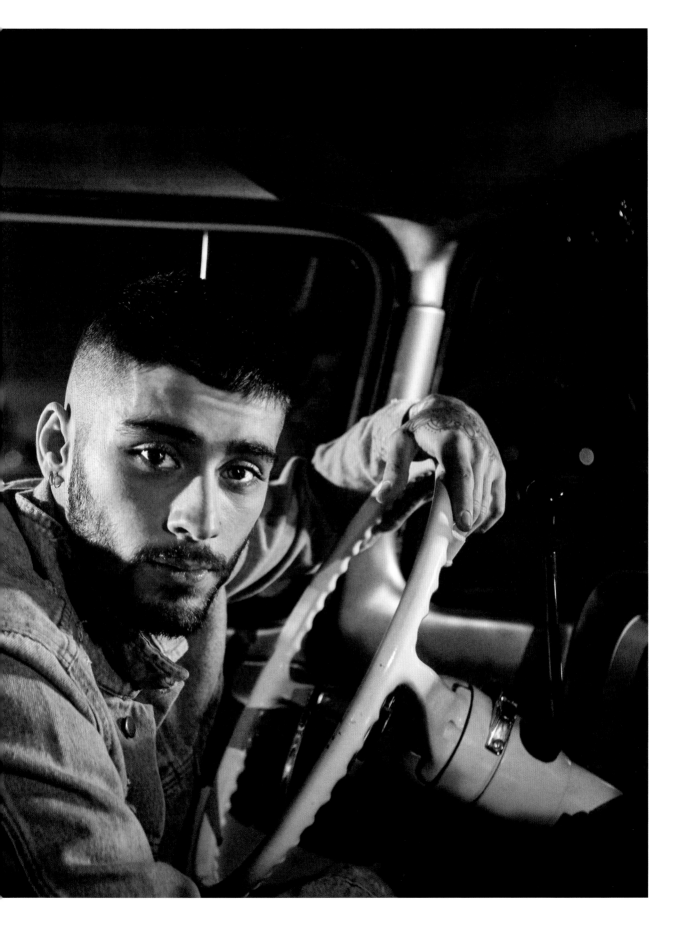

PENGUIN BOOKS

UK | USA | Canada | Ireland | Australia
India | New Zealand | South Africa

Penguin Books is part of the Penguin Random House group of companies
whose addresses can be found at global.penguinrandomhouse.com

First published 2016
001

Text copyright © Zayn Malik, 2016
Photography copyright © Mark Read, 2016
For further credits see following pages

The moral right of the author has been asserted

Colour reproduction by Altaimage Ltd
Printed in Italy by Printer Trento S.r.l

A CIP catalogue record for this book is available from the British Library

ISBN: 978–0–718–18575–6

www.greenpenguin.co.uk

Penguin Random House is committed to a
sustainable future for our business, our readers
and our planet. This book is made from Forest
Stewardship Council® certified paper.

# PICTURE CREDITS

# SONG CREDITS

## Pillowtalk

(Zayn Malik, Levi Lennox, Michael Hannides, Anthony Hannides)

Published by Drop Zed Publishing Ltd (PRS), BMG Rights Management (UK) Ltd (PRS) (a BMG Company), Sony/ATV Tunes LLC (ASCAP) obo Sony ATV Music Publishing (UK) Limited, Joe Garrett Publishing Designee

## It's You

(Zayn Malik, James Ho, Harold Lilly)

Published by Drop Zed Publishing Ltd (PRS), Bhamboo Music Publishing/Bughouse (ASCAP), Uncle Bobby Music/EMI Blackwood Music, Inc. (BMI)

## Befour

(Zayn Malik, James Ho, Harold Lilly, Terrance 'Scar' Smith)

Published by Drop Zed Publishing Ltd (PRS), Bhamboo Music Publishing/Bughouse (ASCAP), Uncle Bobby Music/EMI Blackwood Music, Inc. (BMI) Melkeon Music Publishing/Chrysalis Music (ASCAP)

## Drunk

(Zayn Malik, Alan Sampson, Michael Hannides, Anthony Hannides)

Published by Drop Zed Publishing Ltd (PRS), BMG Rights Management (UK) Ltd (PRS) (a BMG Company), Sony/ATV Tunes LLC (ASCAP) obo Sony ATV Music Publishing (UK) Limited

## Intermission: Flower

(Zayn Malik, James Ho)

Published by Drop Zed Publishing Ltd (PRS), Bhamboo Music Publishing/Bughouse (ASCAP)

## Rear View

(Zayn Malik, James Ho, Harold Lilly)

Published by Drop Zed Publishing Ltd (PRS), Bhamboo Music Publishing/Bughouse (ASCAP), Uncle Bobby Music/EMI Blackwood Music, Inc. (BMI)

## Fool for You

(Zayn Malik, Chase Wells, James Griffin, Kevin Rains, James Emerson, Salvador Waviest)

Published by Drop Zed Publishing Ltd (PRS), Universal Music Publishing, Inc., Sony/ATV Music Publishing, Copyright Control

## Lucazade

(Zayn Malik, Chase Wells, James Griffin, Kevin Rains, James Emerson, Salvador Waviest)

Published by Drop Zed Publishing Ltd (PRS), Universal Music Publishing, Inc., Sony/ATV Music Publishing, Copyright Control

## TIO

(Zayn Malik, Michael Hannides, Anthony Hannides, Herbie Crichlow)

Published by Drop Zed Publishing Ltd (PRS), Sony/ATV Tunes LLC (ASCAP) obo Sony ATV Music Publishing (UK) Limited, 1326 Songs/Songs Of Universal, Inc. (BMI)

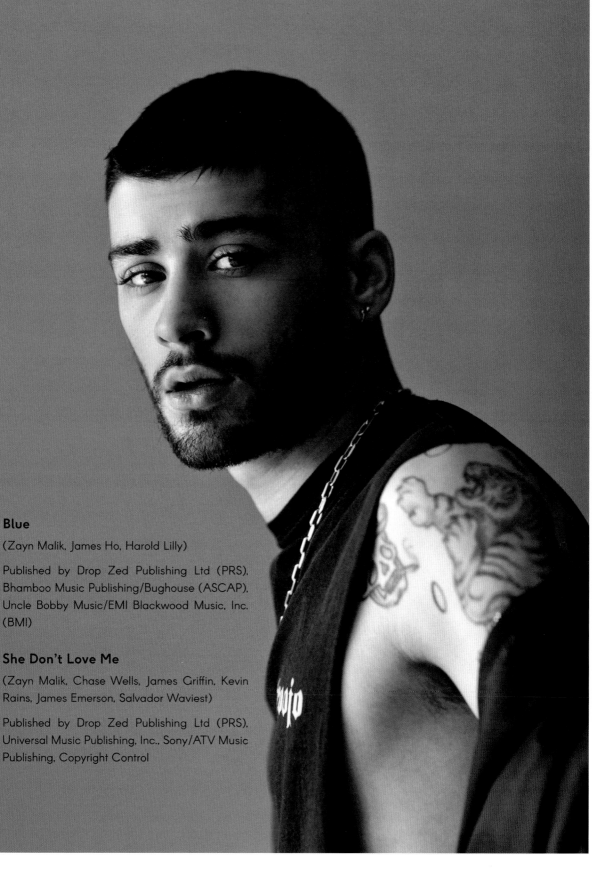

**Blue**

(Zayn Malik, James Ho, Harold Lilly)

Published by Drop Zed Publishing Ltd (PRS), Bhamboo Music Publishing/Bughouse (ASCAP), Uncle Bobby Music/EMI Blackwood Music, Inc. (BMI)

**She Don't Love Me**

(Zayn Malik, Chase Wells, James Griffin, Kevin Rains, James Emerson, Salvador Waviest)

Published by Drop Zed Publishing Ltd (PRS), Universal Music Publishing, Inc., Sony/ATV Music Publishing, Copyright Control